· CINEMA SECRETS ·

SPECIAL
EFFECTS

· CINEMA SECRETS ·

SPECIAL
EFFECTS

· · ·

DAN MILLAR

CHARTWELL
BOOKS, INC.

For Val, Kate and Claire
'Amor vincit omnia'

A QUINTET BOOK

Published by Chartwell Books
A Division of Book Sales, Inc.
110 Enterprise Avenue
Secaucus, New Jersey 07094

ISBN 1-55521-582-3

This book was designed and produced by
Quintet Publishing Limited
6 Blundell Street
London N7 9BH

Creative Director: Peter Bridgewater
Designer: Sara Nunan
Project Editor: Judith Simons
Editor: Linda Wood
Picture Researcher: Linda Wood
Illustrator: Danny McBride

Typeset in Great Britain by
Central Southern Typesetters, Eastbourne
Manufactured in Hong Kong by Regent Publishing
Services Limited
Printed in Hong Kong by Leefung-Asco Printers
Limited

The author and publishers would like to make a
special acknowledgement to the Joel Finler
Collection.

The Publishers would also like to acknowledge the following film companies involved in the distribution and/or production of the films featured in this book:

AIP: *Futureworld.* **Avco Embassy:** The Fog. **Columbia:** *Close Encounters of the Third Kind, The Devil at 4 O'Clock, Dr Strangelove, Ghostbusters, The Golden Voyage of Sinbad, Jason and the Argonauts, The Whole Town's Talking.* **Compton:** *Repulsion.* **EMI:** *Aces High.* **Films du Carrosse/Columbia/Warner;** *Day for Night.* **GFD/The Archers:** *Black Narcissus, The Red Shoes.* **Alfred Hitchcock:** *Rear Window.* **Image Ten:** *The Night of the Living Dead.* **ITC/Dino de Laurentiis;** *Hurricane.* **Laurel Group:** *Dawn of the Dead.* **London Films:** *The Thief of Baghdad, Things to Come.* **Media Releasing:** *Day of the Dead.* **MGM:** *Anchors Aweigh, The Band Wagon, The Clash of the Titans, Grand Prix, Invitation to the Dance, 2001: A Space Odyssey, 2010, The Wizard of Oz.* **New World:** *Hellraiser.* **Orion:** *Amadeus, The Purple Rose of Cairo, RoboCop, The Terminator, Zelig.* **Paramount:** *The Godfather, On a Clear Day You Can See Forever, Raiders of the Lost Ark, Vertigo.* **André Paulvé 1:** *Orphée.* **Polygram:** *An American Werewolf in London.* **Rome Paris/Compton:** *Lola.* **Twentieth-Century Fox:** *The Abyss, Alien, Aliens, Carmen Jones, Chariots of Fire, The Fly, The French Connection, The Return of the Jedi, Star Wars, Three Coins in a Fountain.* **United Artists:** *A Bridge Too Far.* **Universal:** *The Birds, ET the Extra-Terrestrial, Jaws, Jaws II, Marnie, Psycho II, Silent Running, Torn Curtain.* **Warner Bros:** *Batman, Blade Runner, Gremlins, Greystoke The Legend of Tarzan Lord of the Apes, Moby Dick, The Shining, Superman II.*

CONTENTS

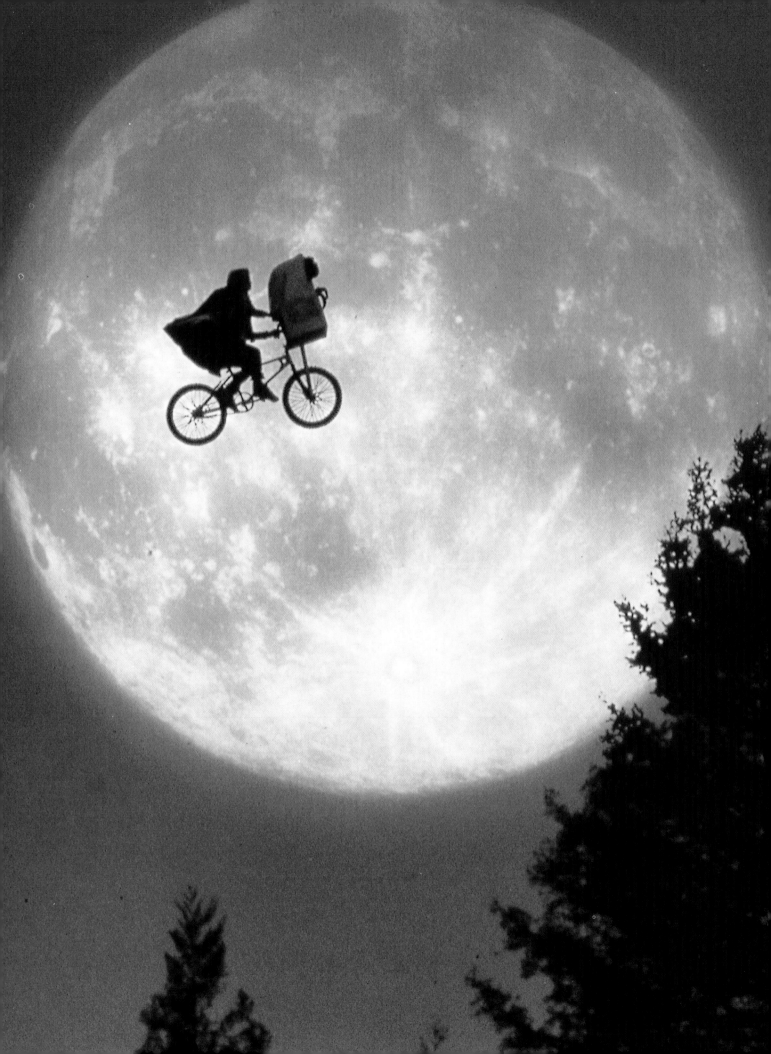

INTRODUCTION

WHY SPECIAL EFFECTS?

Special Effects (SFX) in films are not a strange aberration from the cinematic norm. They are an extension, or a whole group of extensions, of its normal means of expression, with essentially the same purposes: entertainment, excitement, believability (or the sustaining of illusion), telling a story, moving to laughter, gasps or tears — 'In one word, emotion' as the veteran American action director Samuel Fuller memorably put it.

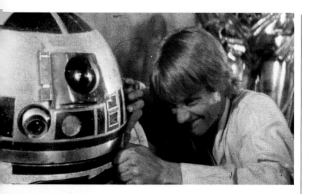

ABOVE In *Star Wars* (1977), technology allows the traditional comic role of the 'low' characters — Shakespeare's clowns or fools — to be given to fictionally non-human droids: C-3PO, who talks a lot, and R2-D2, who just makes noises. Both characters are played by actors.

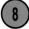

Practically every device of the movies started as a special effect and became assimilated into the everyday language of film, just like metaphor in language. 'This car sucks!' evokes no sexual image, even when comically revived in the 'commercial' for the 6000 SUX in *RoboCop* (1987). This book will therefore explain some of these ordinary means, even though they may be familiar to most moviegoers, as a basis for the extraordinary and generally more elaborate means that are known as SFX.

'Entertainment' in movies as in literature (but not in, say, photography) is largely identified — give or take the odd 'rockumentary' — with fiction, especially narrative fiction. Telling a story means making what is false (or at least largely invented) seem true, so 'realism' (a term hard to define but impossible to avoid) becomes a crucial yardstick of success, a measure of whether the film wins or loses in the game of make-believe, which may also be the serious game of box-office success or failure (though this in turn relates only erratically to the quality of a film in general or its SFX in particular).

Some kind of realism is important whether the movie itself is 'realistic' in reflecting the real world more or less as we perceive it or believe that other people do, or whether it is clearly a fantasy of some kind, set in the future or the distant past or another galaxy or in a present where some of the rules have been changed or abolished, eg time travel is possible, robot androids pass for human, most of the population are zombies, animals speak English, people mix with cartoon characters, or what you will. Television has loosened the hold of realism markedly — and rather oddly, since most of its output is even more rule-bound and 'realistic' than films. Very often, it incorporates real' people, for example in the News, game shows and *Blind Date* (a declining scale of 'realness', perhaps). But TV has also been able to accommodate new forms like *Monty Python's Flying Circus* (1969-74), where narrative logic is a joke or non-existent. Besides, the medium

itself, especially when equipped with remote control, videocassette recorder (VCR) etc invites discontinuity of attention.

While the audience in the cinema now accepts a slackness of narrative logic (though not of narrative drive) that would have been rare and frowned on in the 1940s, it still expects — even in a send-up — more than token adherence to the rules of the genre or of the individual film type itself: horror, sci-fi, the Spielberg 'Indiana Jones' series, the Lucas *Star Wars* series, the Broccoli 'James Bond' series etc. Films that have departed widely from 'realistic' expectations, for example the Astaire/Rogers musicals of the 1930s and the great MGM musicals of the '50s in which people start singing and dancing in the street to the accompaniment of an invisible orchestra, have followed an alternative set of rules, drawn originally from the theatre — theatre proper doesn't need realism, since it has reality.

Special Effects, therefore, like fiction in general, make the unreal seem real, true to life. Seeming true, or 'verisimilitude', is an aspect of realism that depends largely on detail, even on superfluous detail. If you volunteer the irrelevant information that an imaginary character's grandfather was a fishmonger, this gives him a history, an added dimension, that makes him more real. (In *Blade Runner,* 1982, the most advanced androids are given childhood 'memories', borrowed from real

ABOVE In *Blade Runner* (1982), the sophisticated android Rachael (Sean Young) greets the bounty hunter Deckard (Harrison Ford) on behalf of her 'father', the head of the Tyrell Corporation. Tyrell has equipped her with his niece's childhood memories, so she is unaware that she came into existence fully grown.

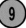

humans, so that they will seem real to themselves.) SFX therefore depend on significant detail, whether or not apparently irrelevant. Such detail is often produced in special ways and by special means, with constantly developing equipment, though not necessarily developed by SFX departments or companies, or by the kinds of specialists who win Oscars and Oscar nominations in this field.

One of the crucial skills in the art/science of SFX is knowing just how much detail is needed or desirable. 'Enough or too much' might be the poet/painter William Blake's prescription for life, but the SFX director must stop short of too much, since added detail is added time and above all, money — as well as possibly being artistically counterproductive. But stinting excessively would probably damage his reputation more than overspending. The cinema industry has always thrived, or survived, on colossal waste — the worst-kept secret of the American film industry, if not of the American economy in general, and probably the real reason for the continued and apparently unshakable worldwide dominance of Hollywood.

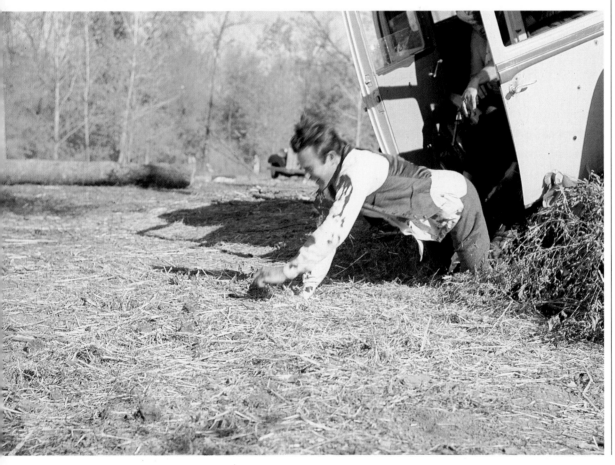

LEFT In *Bonnie and Clyde* (1967), bank robber Clyde Barrow (Warren Beatty) crawls out of the car after being wounded in a police ambush. His brother Buck (Gene Hackman) has been fatally wounded and sister-in-law Blanche (Estelle Parsons) has been blinded. In its time, this was considered a very violent film, partly because it used lots of loud bangs and prop blood, partly because of director Arthur Penn's success in conveying physical sensations vividly.

The special ways and means employed by special effects artists may include filming backgrounds or actions or even people to create an illusion of everyday reality. Such ways and means may be resorted to because the real thing is unavailable, or too expensive, difficult or dangerous. But equally they may include or consist of creating a fantasy world or series of events or actions, or indeed creatures, higher or lower forms of life, so that disbelief is temporarily suspended, and the fantasy seems like a different kind of reality, often momentarily preferable to the spectator's actual experience. Even if horrific or frightening, it's at least more exciting, less routine and ultimately the bad things — being skewered by a maniac or blown to pieces or vampirized — are happening to someone else.

However, SFX are not limited to the work of those designated in the credits or cited in the Academy Awards as visual effects or sound effects specialists; they can also be the task of the make-up artist, the stuntman/woman, even the costumier. In the The Cook, the Thief, His Wife and Her Lover (1989) the wife (Helen Mirren) wears red Gaultier dresses in the restaurant, but these turn to green in the kitchen or white in the washroom to match the decor and lighting. Is this a Special Effect? Not in the sense that the term is being used here, since the changes are arbitrary, not motivated, and not consistent (the waitresses' uniforms remain red in the kitchen). The Cook . . . is an art movie, referring as much to Rembrandt, Vermeer, Frans Hals and Dutch/Flemish still-life painting as to films noirs about brutal gangsters and downtrodden molls. Apart from a few straightforward effects (slow motion, freeze frame), art movies tend to fall outside this area, because by and large SFX are expensive and time-consuming, whereas art movies of limited appeal tend to be made on relatively low budgets. An expensive film may well be a flop (Blade Runner cost $27 million yet took under $15 million in North American (NA) rentals, which are traditionally supposed to cover negative — that is production — costs for break-even); the fact that it was intended to be profitable puts it in the domain of popular cinema.

To take unambiguous examples from big hits, the death scene at the end of Bonnie and Clyde (1967, NA rentals $27.8 million) is clearly an instance of 'realism', very physical and immediate and based on a real-life event. Yet it is also stylized, very arty in its slow motion and repetitions, grotesquely exaggerated in the number of bullet hits scored on both bodies (by the usual device of small charges and sachets of 'blood') and staged quite artificially. Bonnie (Faye Dunaway) had one leg strapped out of sight to the gear lever so that she could slump right

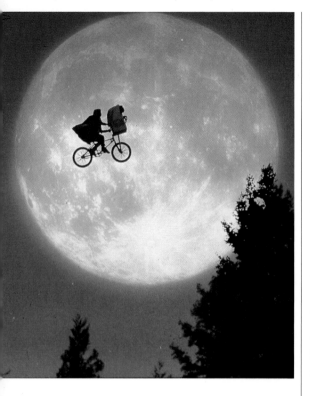

over without actually falling out of the car. By contrast, the scene in *ET The Extra-Terrestrial* (1982, NA $228.6 million) where ET and the children ride their bicycles off the ground and across the sky is clearly fantasy and was accomplished with two-foot-high (60-cm) models, using computer-controlled 3-D animation.

A further refinement is the fantasy sequence within an otherwise realistic context. Though this sometimes occurs within musicals, the clearest examples are dream sequences within melodramas, particularly of the 1940s and '50s. Hitchcock's *Vertigo* (1958) provides an excellent instance. After Madeleine (Kim Novak) has seemingly fallen to her death, the acrophobic ex-cop Scottie (James Stewart) relives the event, mentally re-enacting her fall from the bell-tower to the roof of the Spanish mission. Starting with outright animation, the sequence concludes with a most unusual instance of overt travelling matte. Following a shot of his diminishing body in black silhouette as it falls on the background roof (the viewpoint is vertical from above), we actually see the other half of the matte itself repeat the action as his body falls, a diminishing form on a blank background — possibly a unique example of this type of effect and audacious even for Hitchcock.

ABOVE In *ET the Extra-Terrestrial* (1982), the children enjoy a feeling of lightness and freedom — in contrast to the lack of freedom inherent in real, dependent childhood — by cycling up into the air to escape the adults pursuing ET. But again, in reality, they have to become animated puppets to achieve the effect.

A BRIEF OVERVIEW

Ignoring sound effects for the moment, SFX fall into two main categories: manipulation of the image, and manipulation of what is in front of the camera. (A third category, in practice, is both together.) Manipulation of the image depends in turn on two principal factors, extension in space and extension in time.

The image in film is a two-dimensional (2-D) rectangle, a 'frame', which would normally represent what was in front of the camera during an exposure of $1/50$th of a second. When a series of such images, running vertically down a strip of film, is projected at 24 frames a second (fps) in the cinema, or 25 fps on (British) TV, an illusion of movement is created because of a retinal property known as 'persistence of vision', which in normal life enables us to perceive the world as a continuous flow, not an infinite series of separate moments.

Because different lenses are used for different purposes (for example, a wide-angle lens gets more visual information on-screen than a close-up lens), even in straightforward recording, it could be argued that any photographic image is already a distortion of what one sees in the real world. No camera lens can match the flexibility of the human

eye and only a few experiments in stereoscopy attempt two-eyed (binocular) vision, essential to true 3-D perception.

The most familiar, though normally invisible, additional distortion is that of the wide-screen processes, which squash the images sideways to fit them onto 35mm film and stretch them again for projection. Some wide-screen processes use a wider film, 65mm, in shooting — known as 70mm, since the projection version has 5mm for sound-tracks. But the usual squashing and stretching still applies to most projection prints, except for a few large cinemas in major cities which are able to afford the expensive 70mm projectors. The only well-known process that used 35mm film and an unsquashed image was VistaVision. This shortlived system of the 1950s ran the film itself sideways (as in an ordinary still camera) through a specially designed movie camera, giving an image about 37mm wide and 'true' in the same sense as an ordinary non wide-screen (Academy ratio) 35mm image is — or was. This unique combination led to the rediscovery of the VistaVision process, or at least the old cameras used to achieve it, in the 1970s and '80s as a valuable tool for the SFX cameraman.

BELOW This publicity shot for *Vertigo* (1958) itself incorporates a special effect not seen in the film itself, but expresses an essential theme. Kim Novak as Madeleine (left) is the cool, blonde fantasy character that Scottie (James Stewart) falls in love with. But Judy (right), who created 'Madeleine' as part of a murder plot, is unable to win his love except by reverting to the role. Judy-as-Madeleine is only one on-screen character — the two faces of Judy do not and cannot appear simultaneously.

10344-7

13

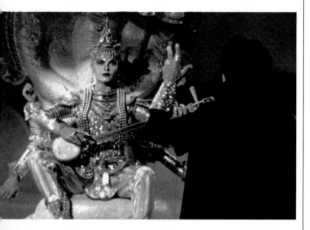

ABOVE *Day for Night* (1973) reveals many tricks of the trade, from a reverse slap (pulling <u>away</u> from the face and subsequently printing the shot backwards) to artificial snow — not to mention the blue filter that turns day into night.

TOP Despite having no less than six directors, *The Thief of Bagdad* (1940) was unified by the vision and energy of its producer, Alexander Korda. Here the wicked vizier, Jaffar (Conrad Veidt), approaches the multi-armed goddess Halima (Mary Morris).

subdivided into parts. Different sections can be masked off in various ways (for example, by a black card or a partial image painted on glass, partly left clear) and exposed separately — either to give a composite that looks like a single image, or to show multiple images at once. This can be done with one frame or strip of film, or the stages can involve successive strips and rephotographing, although with some possible loss of quality each time. The masking can be consistent (for example, top/bottom, left/right, middle/edges) or it can change from frame to frame. The photographic image can be tampered with manually; it can also be tampered with by being made darker or lighter or by altering the colours or colour balance. Again the 'norm' itself is somewhat arbitrary in black and white and still more in colour, where, for example, many actors gain a reddish tone in their hair because the colour is balanced to give 'acceptable' pinkish/brown skin tones.

The extension of the image in time lends itself to distortion by running the camera faster or slower than 24 fps (or even backwards, as with the reversed slap across the face in Truffaut's wonderful film about film-making, *Day for Night,* 1973). This goes back to the very infancy of the cinema, when the camera was hand-cranked and therefore almost instantly variable in speed. Norms of 12-16 fps had risen to 20 fps by the 1920s, and in effect to 24 fps (at least in projection) by the time the coming of sound made standardization compulsory. Shooting and projection speeds had to be identical for dialogue scenes. During the silent era, projection speeds, also initially hand-cranked, tended to keep slightly ahead of shooting speeds (a 1920s Hollywood film, tolerable at 24 fps, may look laboured and slow if run at the — actually amateur — 'silent' speed of 16 fps).

Slight variations, then, are almost imperceptible. Does anyone ever notice that a 100-minute film loses four minutes in British TV screening? (If so, it's probably presumed to have been slightly cut.) It's hardly more noticeable than the fact that, as the Swedish director Ingmar Bergman likes to point out, the cinema audience is sitting in total darkness for 50 minutes of that time, while the projector beam is masked during the change of frame — the indispensable 'intermittent movement' of movie film as it goes through the projector's gate.

If more than 24 frames are exposed each second, the projected movement appears slower (slow motion). If fewer, it's faster, either a little or a lot, depending on the speed of the camera — the projector speed is, of course, constant. If only one frame at a time is exposed, with a delay in between (stop motion), movement is not so much speeded up as created artificially: this is the basic principle of

animation in all its forms. The subject can be two-dimensional (a painted 'cel', originally on transparent celluloid or a scenic painting on glass) or three-dimensional (a model, a flexible figure). The camera makes them seem four-dimensional – solid figures moving in time. But all-out animation, though not rare in the SFX context, is an extreme case. It is, once again, realism that demands the slowing down of the little waves in a studio tank to simulate the big waves of the ocean, or stretching the fall of a toy-sized car off a desk-high 'cliff' to the time of a real car falling of a real cliff.

The mention of several major front-of-camera elements in connection with manipulating the image demonstrates that the two aspects are inseparable in practice, though they may be divided for ease of explanation and clarity of illustration. Such subject elements include: small things passing for large (models, miniature sets); large passing for small or normal sized (eg an oversized set if normal people are supposed to be miniaturized); animate for animate (stuntman; stand-in; actor or child or dwarf inside animal or creature); inanimate for animate (from the cel of the animator to the monster or creature constructed in miniature or full scale and made to move by electrical/mechanical/hydraulic means or by stop-motion animation); animate for inanimate (pseudo-mechanical effects operated by muscle power; the androids, played by normal actors, in *Blade Runner*); composite for single images (rear or front projection of the setting or alternatively the action, or one person playing two roles on screen simultaneously); 2-D for 3-D (glass paintings, painted backdrops).

Slightly outside these catagories are make-up, wigs etc, the major elements (fire, water etc), and computer-generated graphics, which can vary at will from abstract to convincingly 3-D. The latter have not yet really taken root in movies, but may be one of the major developments of the 1990s.

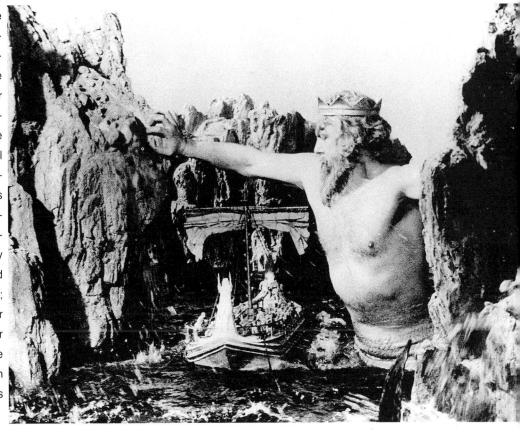

BELOW In *Jason and the Argonauts* (1963), Ray Harryhausen contributed a variety of special effects. Here the *Argo* is negotiating the Symplegades, rocks that operate like jaws to eat up unwary ships; luckily the goddess Hera has sent a Triton to help Jason and his crew. This extract was shown on quite a big screen at the MOMI (Museum of the Moving Image) Harryhausen exhibition in London and the modelwork remained convincing — and exciting.

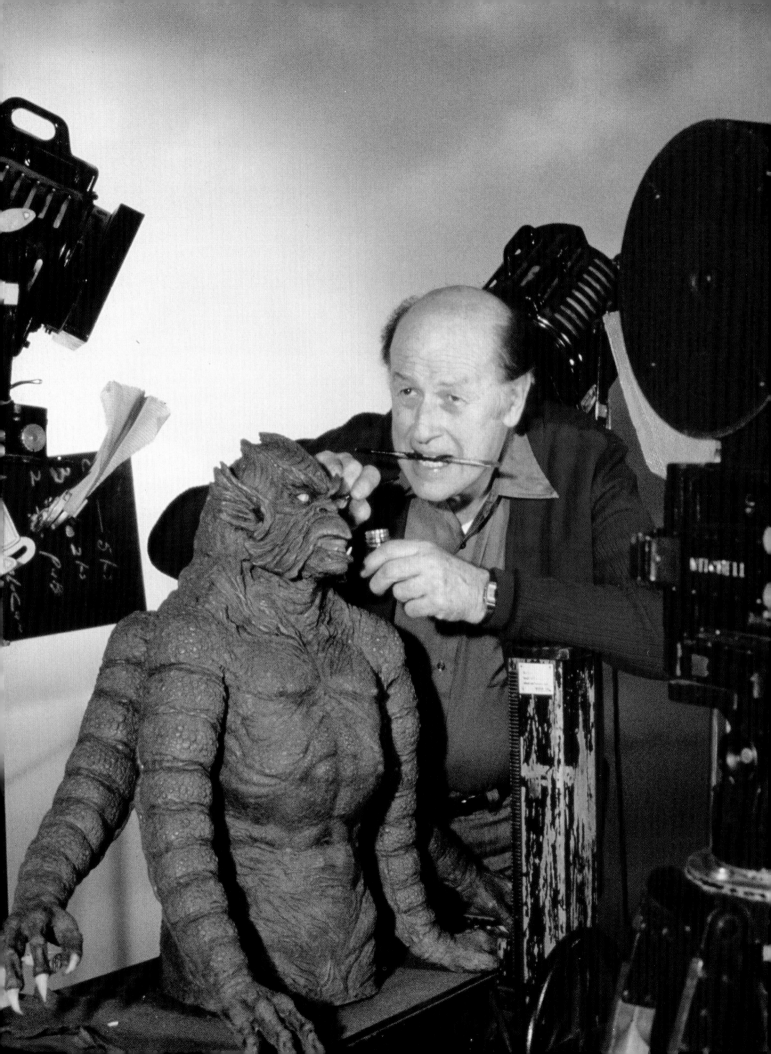

EDITING

Editing was born from the simple ability of the camera to stop and start at will, soon supplemented by the possibility of cutting and rejoining the film. The early French film-maker Georges Méliès is reputed to have discovered the magical properties of 'cutting' in-camera when, in 1896, he was recording the flow of Parisian traffic; he stopped and restarted the camera and later found that the scene had been transformed in an instant.

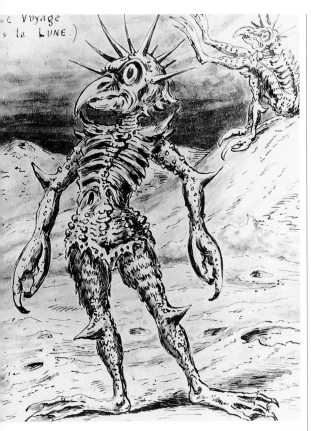

ABOVE One of Georges Méliès' own designs for the moon monsters in *A Trip to the Moon* (1902).

The cut is still crucial to SFX, since it enables the director to leap instantly between different levels of reality and illusion; eg stuntman *cut* close-up of actor *cut* stuntman, in for example, Tim Burton's *Batman* (1989), where Michael Keaton, as Batman, is not required to personally perform sensational wirework acts of falling or climbing. Or again, miniature of a city street *cut* full-size vehicle in front of full-scale set. In John Huston's *The Dead* (1987), only a cut separates an indoor street set (late at night, so no background is needed, just a house, a bit of pavement, one street lamp and a horse-drawn carriage), ostensibly in Dublin but actually in Valencia, California, from the dark streets of the real Dublin, shot by a second unit with Huston 6000 miles away.

The cut is therefore the most basic device of SFX, the one that knits together a variety of complicated elements into a unity of effect. To cut from a model a few inches long to a close-up of a face — Harrison Ford in the police Spinner in *Blade Runner* — establishes an identity between them. Each special effect is just barely holding on to credibility, waiting for that cut which often comes only just in time (and sometimes a fraction late). Though 45 stunt people were employed in *Batman* and they were heavily used in the final rooftop battle, it is a dummy that takes the Joker's final long fall from the roof of Gotham City cathedral, possibly enhanced by a rotoscope artist who put in the diminishing image frame by frame.

In an earlier film directed by Tim Burton, *Beetlejuice* (1988), there are recurrent cuts between the model village built by the Maitlands (Alec Baldwin and Geena Davis) in their attic and full-size sets of parts of the model when it is inhabited by the eccentric spirit Betelgeuse (Michael Keaton) and at times by the Maitlands too — being ghosts, they can change size rather easily, if involuntarily. Again, the purpose is to establish identity between things — settings in this case, people in previous examples — that are in fact not identical. This is in addition to the normal purposes of cuts, such as keeping up the pace of the story,

or giving emphasis to actions or reactions.

The alternative to cutting is, of course, not cutting. This involves increasingly elaborate camera moves the longer the shot is held or else relies heavily on the interest of dialogue if the camera is not moving significantly. In *Orphée* (1950), Cocteau prided himself on using mechanical effects rather than optical trickery for such magical moments as when the characters pass through the mirror to the world of the dead. But he was therefore compelled to cut quite frequently in order to link such effects together persuasively. For instance, a close-up of a hand dipping into a slightly tremulous bath of mercury renders the moment when a character penetrates the mirror. But a cut away is essential then, since the actor cannot enter the bath any further (the next stage of passing through depends on lighting and a duplicate set built as a mirror image to the first).

DISSOLVES

The abrupt cut can be softened by a lap dissolve, originally done by gradually closing down the iris on the lens (a fade-out), winding back the film and then opening up the iris for the same length of time and film (a fade-in). This is now done in the lab by optical printing.

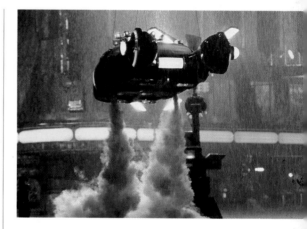

ABOVE The police spinners (propless helicopters) in *Blade Runner* (1982) were made in several sizes. This one is tiny and flies on wires — which are not, of course, seen in the finished film. The full-sized model did not fly at all.

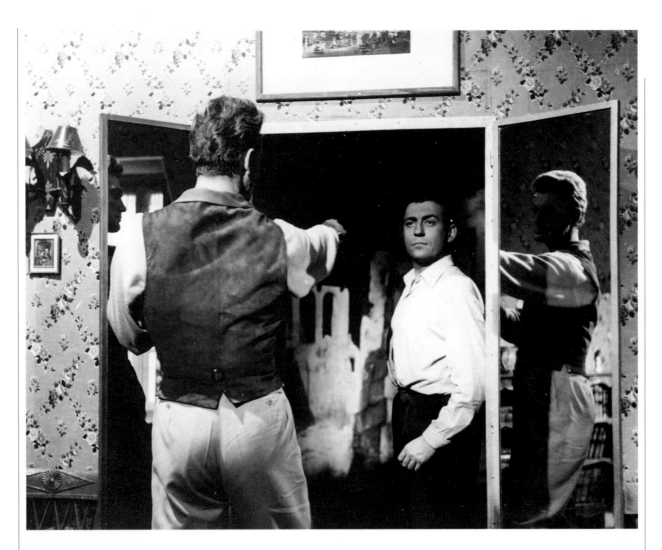

ABOVE In *Orphée* (1950), Orpheus (Jean Marais) is about to pass through the mirror to join the chauffeur 'angel' Heurtebise (François Périer) in the 'Zone' that lies between life and death. In this still, the central mirror has already dissolved, revealing Heurtebise and a back projection of the 'Zone', a real location of war-damaged ruins used in the next sequence. Orpheus must brave the world of death in order to rescue his dead wife, Eurydice, and bring her back among the living.

The effect of an abrupt change, for audiences more experienced than those of 1896, is to alert the viewer to camera trickery, destroying belief. Méliès's first example, the girl turning into a skeleton in *The Vanishing Lady* (1896), is more persuasively achieved by a dissolve in Hitchcock's *Psycho* (1960) when Norman Bates (Anthony Perkins), locked up in jail, is taken over by his 'mother' (that is, his fantasy of the mother he can't admit to having killed) and his face turns into a skull, her skull. Though the effect is purely symbolic, even poetic, as well as chilling, much of its force depends on rapidly cutting away to Marion's car being pulled out of the lake — a banal, everyday detail of the investigation that almost makes us doubt whether we really saw that skull, previously forced on the viewer with horrifying shock impact in the cellar scene.

Though the dissolve has become part of film punctuation it can still shock or seduce the viewer. It is sometimes used in erotic love scenes to suggest the subjectively rapid yet objectively languorous passage of time — meanwhile possibly also concealing that less is being shown than seems to meet the eye.

SLOW MOTION/ FAST MOTION

Fast motion is nearly always comic in effect, unless used very subtly, almost subliminally — the 'crispness' aspired to by silent-film projectionists, perhaps slightly increasing the viewers' pulse and breathing rates. Though slow motion can be comic, it usually is not; rather, it increases viewers' concentration as they try to determine what is being emphasized. Paradoxically, therefore, slow motion can be used to give an impression of great speed, as in *Chariots of Fire* (1981), where the big races are slowed down. The effect is multiple. It conveys strain and effort; the psychological rendering of a concentration on each separate moment and the feeling that every moment will be recoverable in memory (perhaps strobe-like stop-motion would be more logical here, but it could provoke laughter or distraction, a break in concentration on the story); and finally the suggestion that the action is so rapid that it must be slowed down so that it can be perceived at all.

Like dissolves, slow motion can be useful for scenes of sexual love or simply for lovers' meetings — a usage now long derided, though, and so

RIGHT This publicity shot for *Psycho II* (1983) recalled the images of *Psycho* (1960): the lonely Norman Bates (Anthony Perkins), the sinister house above the motel, and in the window the figure of the Mother, an imperfectly preserved corpse, who only comes to life when Norman wears her clothes or imitates her voice.

no longer even parodied, after its long descent through so many TV commercials. The hard-edged anti- romanticism of the 1980s tried to eschew such practices; but the pendulum may well swing back in the '90s. (Hard-core pornography, of course, favours long-held shots, since it is a form of documentary or even *cinéma-vérité,* lightly fictionalized, and instant retakes are not always possible.)

In the very different atmosphere of the late 1950s/early '60s, the New Wave in France and to some extent in Britain and the United States favoured slow motion as a way of rendering privileged moments, at little production cost. Such moments were usually romantic but not necessarily overtly erotic. In Demy's *Lola* (1961), a story of love, time and chance, the teenage girl Cécile (Annie Duperoux) goes to the September Fair in Nantes with an American sailor, Frankie (Alan Scott) whom she has met by chance in a newsagent's shop, buying a comic. He is in love with Lola (Anouk Aimée), a dancer and demi-mondaine, whose real name (unknown to him) is Cécile. Lola is waiting loyally, if not faithfully, for the lover, Michel (Jacques Harden), who fathered her child and abandoned her seven years before. In fact (unknown to her),

BELOW Slow motion paradoxically enhances the effect of speed in *Chariots of Fire* (1981). Vangelis also chose slow rhythms for his haunting music and was justly rewarded with an Oscar.

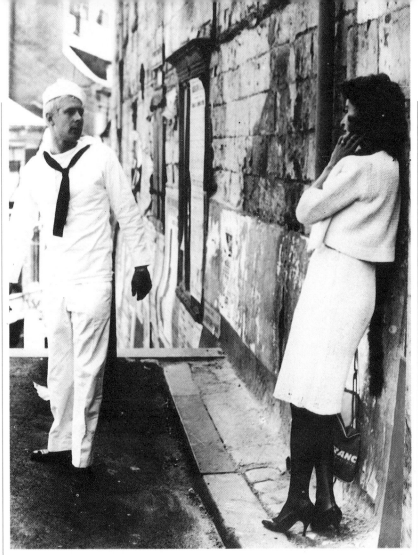

he has returned in a Cadillac, wearing a cowboy hat of purest white, and having made his fortune as promised. To Frankie, the brief excursion to the fair is an escape, a passing interlude, a reminder of his young sister in Chicago, whom he misses. But to Cécile it is the indelible moment of first love, impossible and undeclared. As they leave the fair (moving towards the camera, which pulls back with them), their joyful cries become unheard and they move in slow motion like creatures under water for a few seconds. Love seems a kind of suffering as well as joy — friendship too. Perhaps Demy was consciously drawing on a classic and influential earlier film, Vigo's poetic *L'Atalante* (1934), with its dream underwater effects. But unfortunately the result — though its meaning is clear and analyzable — now looks rather forced and frankly old-fashioned. Indeed, much of the film has dated badly, by comparison with the better American films of around the same time (*Wild River, Psycho, The Hustler, El Cid*), or to put it more neutrally appears less attractive than it did in its own time.

Fast motion can be used to express erotic tension and desire, if the

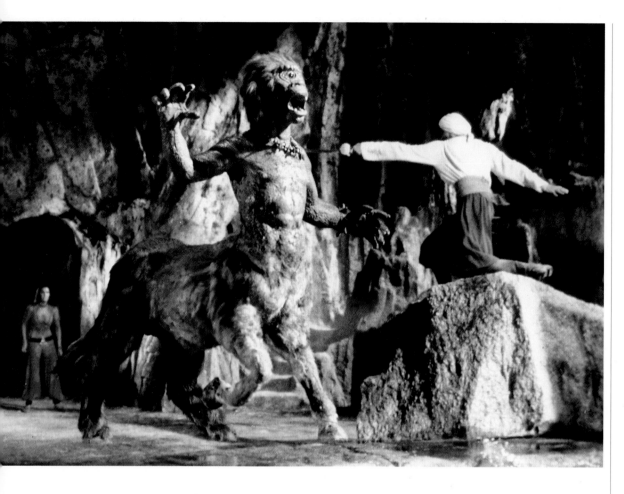

purpose is comic rather than romantic — if we had laughed at the romantic yearnings of Cécile or even Frankie, the film would be failing, even though the treatment of these themes is throughout as much comic as tragic — 'bitter-sweet' seems to be the compound word, or better still the *mot juste* is *'douce-amère'*.

But the famous scene of greedy eating in *Tom Jones* (1963), in which Tom (Albert Finney) and Mrs Waters, aka Jenny Jones (Joyce Redman) — who may be his mother but luckily turns out not to be — rush through a huge meal in order to get to bed and 'devour' each other, actually replaces the sex scene which it appears to be prefacing. The physicality of their food consumption, decidedly hands-on, and their mutually greedy looks say it all.

Finally, fast motion can, after all, express speed, especially when it is used subjectively, as in so many car chases — the one in *The French Connection,* 1971, is a better example than most, and includes similar speeded-up shots of the subway/elevated railway. In the computer graphics of *Tron* (1982) we are right down on the board with the players

ABOVE Ray Harryhausen's films combine small-scale puppet animation with live action, often using back projection for economy. In *The Golden Voyage of Sinbad* (1973), Sinbad (John Phillip Law) fights the Centaur while slavegirl Margiana (Caroline Munro) attemps unsuccessfully to distract the one-eyed monster with a generous display of cleavage.

of video games, even if we don't quite share their viewpoint; the motorcycle shots, much quoted, show how exhilarating rapid movement along wholly imaginary perspectives can be.

STOP-MOTION/ SINGLE-FRAME ANIMATION

If the camera shoots single frames at stated intervals (one second, one minute, one hour, one day . . .), that's time-lapse stop-motion. If the intervals are not regular but are simply the time it takes the operator to change the subject and are not perceptible, it becomes stop-motion (or single frame) animation proper — the movement is created, but not actually recorded.

The commonest example of time-lapse stop-motion used to be in biology films, like the old Rank *Secrets of Nature* by Mary Field or innumerable educational films for schools from companies like Encyclopaedia Britannica Films. The growth of, usually, a flower is recorded in single frames spaced out over hours or days; schools could even conduct this type of experiment with suitable 16mm or 8mm equipment.

The same effect is used wonderfully in the opening credits of Minnelli's most underrated musical, *On a Clear Day You Can See Forever* (1970). While the physically gifted and superhumanly green-fingered Daisy Gamble (Barbra Streisand) sings 'Hurry, It's Lovely Up Here', the flowers on the roof of her apartment block, mostly tulips grow at an alarming yet beautiful rate, conveying a sense of freedom brimming over with life. This is communicated also to the flowers around the building at the university where Dr Chabot (Yves Montand) lectures on hypnotism. Her life-enhancing power contrasts with the stunted hopes and thwarted sexuality of the subdued, passive Daisy — until she returns under hypnotism to a previous incarnation in Regency Brighton and London as a highly sexed witch.

What might have been just an isolated, if pretty, trick effect is thoroughly integrated into the thematic content of the film in characteristic Minnellian style — though the evidence of interviews sometimes suggests that this aspect of his work, unlike the stylish and carefully contrived visuals themselves, is in part unconscious and instinctive.

By contrast, death and decay are speeded up in the equally characteristic Peter Greenaway film, *A Zed and Two Noughts* (1985),

BELOW In *The Birds* (1963), the children of Bodega Bay are attacked by birds as they leave the school — but only on film. The birds are matted in, probably by rotoscoping, a frame-by-frame animation technique. Melanie (Tippi Hedren), seén trying to help the girl, was subjected to real birds later on in the shooting schedule.

set mainly in a zoo. The zoologist twin brothers (Brian and Eric Deacon), following the simultaneous deaths of their wives in a car accident, become fascinated with recording death and decay. The corpse of a zebra, under the camera's necessarily impassive gaze (some viewers are queasier), is reduced almost to a skeleton as skin and then flesh are progressively stripped away by the processes of nature.

Two-dimensional stop-motion animation of flat pictures — such as the cels used in cartoons — is a topic complex enough for a separate book. For a start, though it's called 'single-frame', two frames are often shot at a time, for economy. Furthermore, the very best of Disney (for example, *Pinocchio,* 1940) actually used multi-plane pictures. These are a bit like pop-up books with foreground, middle ground and background to give perspective and, in movement, parallax, that is, near things apparently moving past each other in the foreground and middle ground while the background stands still, which is how motion is perceived in the real world seen from, say, a train.

The same basic principles of animation can be applied when animating 3-D objects, where in fact perspective is usually built-in anyway. This occurs in puppet animation, much developed in

BELOW In *Anchors Aweigh* (1945), Gene Kelly, choreographing himself, taught Jerry Mouse to dance 'The Worry song', aided by animators Hanna and Barbera.

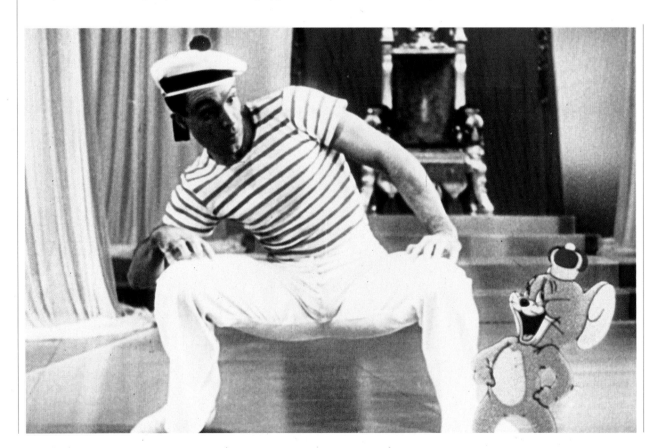

Czechoslovakia at one time by Jiří Trnka among others, and certain kinds of art animation developed by the Czech Jan Švankmajer and his admirers, the British-based American Quay Brothers. Both kinds of animation and their techniques (for example, rotoscoping, which will be discussed later), besides being art forms in themselves, are used as adjuncts for SFX, normally in combination with live action or other kinds of effects. The birds in *The Birds* (1963) are sometimes animated, usually in combination with live birds and/or models. But this kind of animation is intended to be 'invisible' and would lose its effect if obviously or obtrusively noticeable. Overt mixing of live action and animation, specifically cartoon animation, does occur, but rarely, and only in certain kinds of fantasy films. (Technically it depends on the use of travelling mattes, explained in Chapter 2.) Before *Who Framed Roger Rabbit* (1988), where the Toons and their interaction with live people are part of the story (indeed, its main theme), such mixtures appeared only in occasional musicals. Among the best remembered are *Anchors Aweigh* (1945), in which Gene Kelly as a sailor on leave in LA, teaches Jerry Mouse to dance; Kelly again in the 'Sinbad The Sailor' segment of *Invitation to the Dance,* with music from Rimsky-Korsakov's symphonic suite, *Scheherazade;* and *Mary Poppins* (1964), in which Julie Andrews and Dick Van Dyke ecounter a variety of Disneyfied animals.

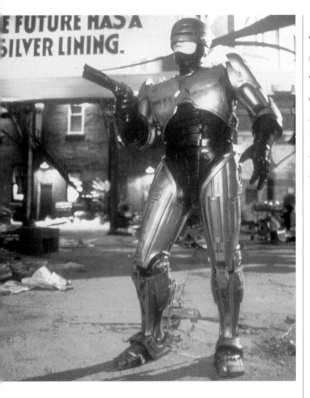

The most interesting aspect of *Roger Rabbit* is the ambiguity about whether the Toons are better or worse than humans — much like the unresolved dilemma of Deckard in *Blade Runner*. They are better *and* worse — better when they are being their simple selves, amusing everyone and faithful as lovers; worse when they disguise themselves as humans (Judge Doom/Christopher Lloyd) and conceal their origins. It hardly takes much decoding to translate this into racial — indeed, not far from racist — terms. The 'happy' ending in which the Toons inherit their own ghetto is in some ways positive, but the Toons remain happy infants — has anyone ever tried to imagine the bedroom scenes of Roger and Jessica? The frenetic rhythm of the animation, which Richard Williams suggests was imposed by the producers, may also quite possibly have something to do with concealing the matte lines where live action and animation join — if so, it succeeds in that respect.

If the mixture of live action and 2-D animation achieved surprising commercial success in the late 1980s ($78m rentals, justifying a cost of over $50m), the combination of live action with 3-D animation seemed to reach something of a dead end with *Clash of the Titans* (1981). Its $17.4m rentals, nevertheless, represented a modestly respectable profit on a $15m outlay (16% compared with 47% for *Roger Rabbit*). The computer has rendered the hands-on animation that created the monsters in this and previous Ray Harryhausen films as outdated, however charming in its way, as the original *King Kong* (1933; effects: Willis J O'Brien), without the mythic power which keeps that minor masterpiece mysteriously fresh.

The comparatively brief use of stop-motion animation (combined with rear projection) in *RoboCop,* notably for the violently ineffective mechanical law-enforcement droid ED 209, and the amiable parody of an O'Brien/Harryhausen dinosaur in the car commercial for the SUX 6000, is a different case, or rather two. The dinosaur is supposed to look comically unfrightening — the humour here is broad. The darker humour associated with ED 209, which does indeed look quite large and threatening at first (and not at all like a model only one foot (30cm) high, which it is) is typified when it, in error, riddles a young executive with machine-gun bullets on its first official presentation and the stunned silence is broken by a cry of 'Someone send for a paramedic!' (Well, a doctor would be no use, except to sign the death certificate.) Its sponsor hints at an apology for the mayhem by suggesting that it's a glitch, a temporary snag to be overcome. Already the blackest of black comedy, enriched by Verhoeven's European sense of irony, *RoboCop* is a self-parody that cannot be ridiculed.

TOP This publicity shot for *RoboCop* (1987) underlines the ironies involved in 'cleaning up' Old Detroit for its profitable redevelopment.

ABOVE Ray Harryhausen, an American animator long resident in Britain, works on his model of the Kraken, the monster from the deep, in *Clash of the Titans* (1981).

OPTICAL DISTORTION/ ZOOM LENSES ETC

Any kind of overt optical distortion can only be an occasional isolated effect for a clearly marked purpose, such as rendering the subjective experience of someone under stress or drunk or dreaming. Directors who tread the border between realism and fantasy — Hitchcock, Powell, Polanski — are particularly likely to use such effects: for a repressed memory (Gregory Peck's false doctor in *Spellbound,* 1944); for repressed alcoholism (David Farrar's Sammy in *The Small Backroom,* 1949; USA *Hour of Glory*); for repressed sexuality (Catherine Deneuve's mad Belgian girl in *Repulsion,* 1965).

ABOVE This unusual production shot for *Repulsion* (1965) graphically expresses the tedium of much film-making. Catherine Deneuve, as a lovely mad girl experiencing paranoid fantasies of molestation, waits patiently to run the gauntlet of groping hands once again. Production people check or confer while the anonymous extras droop quite un-erotically. The scene was shot for the film with a wide-angle lens in order to force the perspective.

A more regular form of distortion was the use of zoom lenses, changing focal length *during* a shot, in the 1960s. A zoom lense is the visual equivalent of a continuous gear shift in a car: merely by turning a handle, the operator can move from a long lens, giving a narrow view but a deep-focus telescopic shot of the subject, to a short, wide-angle lens, with a wide view. If merely set at a given focal length, the zoom lens will simply act as a normal though infinitely variable lens (between its limits) and the viewer will be unaware that it has been used at all. When moved, it gives a perceptibly false sense of movement, as if tracking in or out but without the change of perspective that would accompany a genuine movement. Since the distance and aperture remain the same, only more or less of the same picture is being shown, just as if a camera in a museum or on an animation stand were moving in and out on an oil painting. This artificiality led to the zoom shot's falling out of favour for all but occasional use (how it helped Superman to fly will be discussed later on).

A simple but effective example of its very artificiality occurs in *Marnie* (1964) when, towards the end, Marnie (Tippi Hedren) tries to steal

money from the Rutland and Co. safe; her simultaneous attraction and repulsion is shown by rapid zooms in and out, brief and repeated. The static viewpoint is here entirely apt: it is her emotions that are fluctuating, not her vision.

For a really weird effect, it could be combined with an actual camera movement in the opposite direction (tracking in and tracking out, so called because it used to be done on tracks like tramlines rather than free wheels). This is how Hitchcock created the vertigo effect in *Vertigo* (1958) when Scottie (James Stewart) looks down the stairs of the bell tower. Actually the church had no tower — it was matted on to the exterior and the interior was built in the studio. But for the vertigo shot alone, a horizontal miniature was built to avoid counter-weighting the heavy VistaVision camera. In the Truffaut interview book, Hitchcock agrees when Truffaut suggests it was a forward zoom (ie zoom-in) combined with a reverse tracking shot. Donald Spoto supports this in both his books about the director. Yet in his interview with the editors of the magazine *Movie* Hitchcock agreed when they suggested it was a

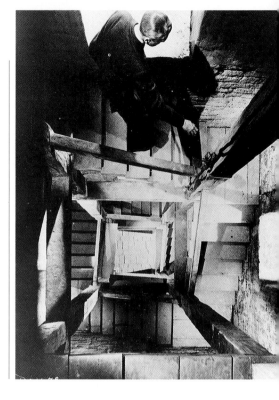

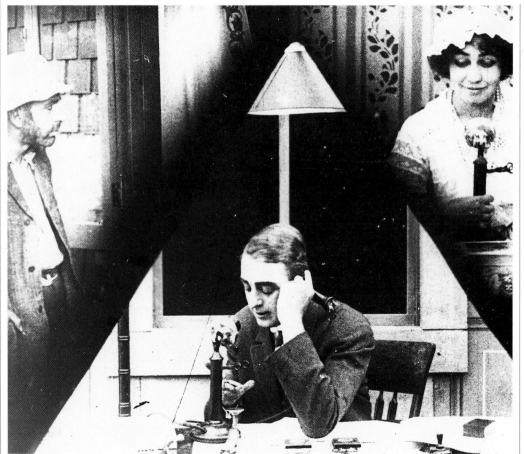

ABOVE In *Vertigo* (1958), Scottie (James Stewart), shattered by the 'death' of the false Madeleine, descends the stair of the tower at the Spanish mission. The real location had no tower and Hitchcock had a 70-foot (21.3-m) model built in the studio. He also had a miniature horizontal version made for the subjective shot of Scottie's vertigo, a simultaneous tracking shot and zoom in opposite directions.

LEFT This triptych shot from a silent film, *Suspense* (1912), shows a husband and wife talking on the phone while a prowler is about to menace the wife.

zoom-out while the camera tracked in, the precise opposite. Since this shot occurs in two different scenes, maybe he tried it both ways, but it looks the same in each, though repeated inspection fails to disclose conslusively which of the two possibilities it actually is. Anyway, it works.

MULTIPLE IMAGES/ SPLIT SCREEN

If zoom shots have dated, multiple images and split-screen effects have long disappeared from regular use. Again, this was a 1960s fad which lasted only a very few years (c 1966-69), although split-screen sequences had occasionally appeared in fantasy films such as musicals in the 1940s and '50s. But it was used earlier still in silent films, for telephone conversations. An example occurs in a more recent film, *When Harry Met Sally . . .* (1989), where a period feel is aimed at in the earlier parts of the film though the period is as recent as 1983. Both Harry (Billy Crystal) and Sally (Meg Ryan) are simultaneously watching *Casablanca* in their own bedrooms and discussing it by phone as it ends. So we see the two TV images, Sally's sharp and contrasty, Harry's dull and grey, and the backs of their heads as they converse, with their heads virtually touching except that they are divided by the split and, of course, by the distance between their apartments.

A tantalizing, much earlier example occurs in *The Band Wagon* (1953), though not involving a phone and unfortunately cut from the release print (A surprising number of musicals reputedly lose their best production numbers.)

Since *The Band Wagon* is arguably the greatest — as well as most typical — of all musicals (if we exclude *The Chronicle of Anna Magdalena Bach,* 1968, as non-eligible and demote *Singin' in the Rain,* 1952, to second place), one can only wish there were more of it. What survives, outside MGM's archives, of the sequence in which Astaire and Charisse separately rehearse at the barre, is just a few black-and-white stills. Presumably the washed-up film hoofer and the prima ballerina are thinking about each other as a preliminary to working together, falling in love and starting a bright new phase of their respective careers together; and no doubt their movements 'unconsciously' fall into a complementary rhythm as they dance to the same music. This would have been a stage towards the best-remembered dance sequence in the film, prominently featured in *That's Entertainment!* (1974), when they go 'Dancing In The Dark' in a fantasy Central Park, she in a pleated white skirt and flat

ABOVE What would have appeared on-screen in *The Band Wagon* (1953) as split-screen — if the whole number had not been cut — is here revealed as a double set.

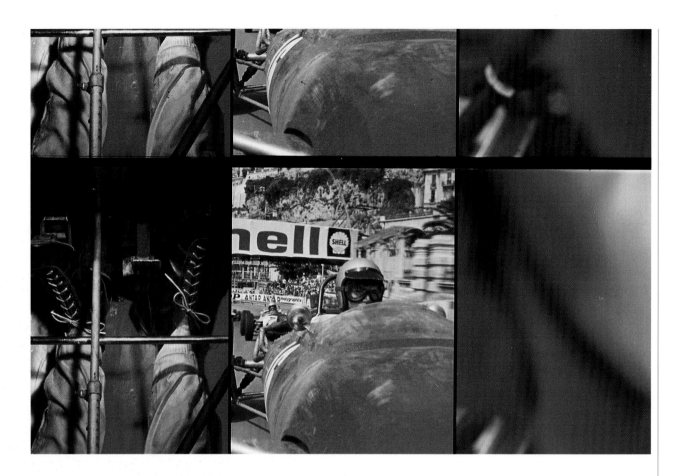

shoes, he in a light sport jacket and slacks, just as they've come from
rehearsal. This magical number may have rendered the split-screen
sequence superfluous; but most Astaire and Charisse fans would
probably give a day's pay to see it once.

Few people, excepting a few insatiable car-racing and real-life murder
fans, would give much to see again such monsters of eyestrain as *Grand
Prix* (1966) or *The Boston Strangler* (1969) which chopped up the screen
mercilessly into segments that seemed as much clashing as
complementary. While in theory multiple images would seem to be a way
of enriching the screen's information, in practice it was usually just
distracting and slowed down the narrative speed. Perhaps in a way it was
more justifiable in the special case of *Grand Prix* where it echoed the
multiple TV-screen images of which the director, John Frankenheimer, is
so fond — perhaps nostalgia for his early days as a director of live TV
drama.

Split screen can be used not as an overt, expressive visual device, but
for illusion. The obvious example is where one actor plays two roles
simultaneously. Danny Kaye first used this trick in *Wonder Man* (1945),

where he played twins (one of them a ghost) and repeated it in variant forms in *On the Riviera* (1951) and *On the Double* (1961). In a slightly more serious vein, Edward G Robinson played a timid clerk, a brutal gangster and the gangster posing as the clerk in *The Whole Town's Talking* (1935). Sometimes other devices, such as stand-ins, supplement the comparatively rigid limits of the split screen. In non-comedies, such as those melodramas where a top female star plays twins, one good, one evil (Olivia de Havilland in *The Dark Mirror,* 1946; Bette Davis in *A Stolen Life,* 1946, and again in *Dead Ringer,* 1964), the director will tend to reduce, if possible, not so much the scenes the two

LEFT In John Ford's comedy-thriller from Columbia, *The Whole Town's Talking* (1935), Edward G Robinson plays nervous clerk Jones (left) and gangster Mannion. Mannion decides to eliminate Jones and take over his identity; but, of course, it is Mannion who ends up dead.

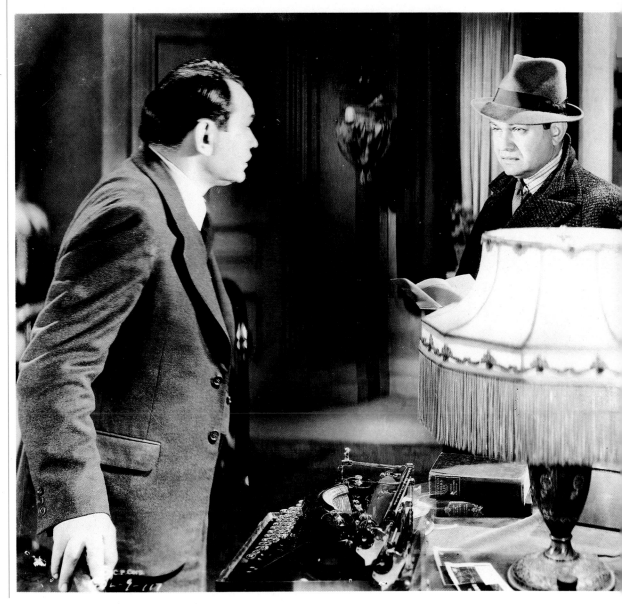

characters play opposite each other as the shots in which they appear on-screen simultaneously. Whereas using the device in the former genre displays acting skill advantageously, its use in the latter is not only more expensive and difficult but tends to draw attention to the technical device rather too obviously. (In fact, Curtis Bernhardt, the director of *A Stolen Life,* claims that both characters were not only on-screen simultaneously but passed each other and interacted without the use of a double, except in a few over-the-shoulder shots; unfortunately he had forgotten when interviewed how this was done. It can only have been back projection, travelling matte or some combination of the two.) On the other hand, the multiple permutations possible — contrast, misunderstandings and confusions of the two characters, each playing the other — are well suited to comedy. Woody Allen, for instance, in *The Purple Rose of Cairo,* has two characters played by Jeff Daniels — the

ABOVE In *The Purple Rose of Cairo* (1985), actor and character confront each other as rivals for the love of Cecilia (Mia Farrow), a New Jersey house-wife. Since Jeff Daniels plays both Gil and Tom, matte scenes were needed for some of their shots together; but in this case a straightforward stand-in (David Weber) does the job.

screen actor Gil Shepherd and his movie character Tom Baxter. The two confront each other as rivals for Cecilia (Mia Farrow).

A recent, more complex example is David Cronenberg's *Dead Ringers* (1988), which arguably starts off as black comedy but ends as something like black tragedy. Jeremy Irons plays twin gynaecologists: shy, introvert Beverly is devoted to his medical work and research; extrovert Elliot is the PR man of their clinic, highly successful with the ladies, not excluding some of the gynaecological patients, whom he shares (unknown to them) with Beverly. One such is Claire (Geneviève Bujold) but Beverly starts to take the relationship seriously, and is upset when she temporarily rejects both of them. A downward spiral of drink and drugs eventually affects both twins — Elliot believes that not only are they partly telepathic but also that they share chemical effects in their blood streams. Finally Beverly kills Elliot in a parody operation and then kills himself. He dies lying across his brother's body, a complicated split screen effect in which Irons was first Elliot, sprawled half-sitting against the wall with a stand-in across his lap, and then Beverly lying in exactly the same position as the stand-in for a matte shot to be inserted in the first image. This, the last shot of the film, is also the most memorable.

RIGHT This elaborate set for *Rear Window* (1954) is for much of the film seen only from the window of Jeff (James Stewart), a roving news photographer confined to his apartment with a broken leg. He spies on his neighbours with his array of lenses, and discovers one of them is a wife-murderer.

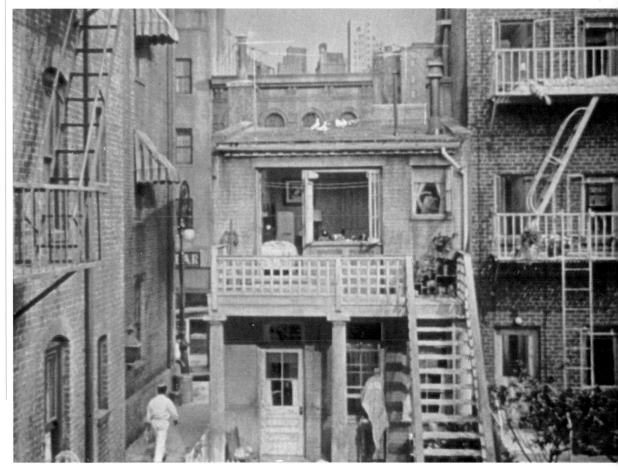

Multiple passes through the camera increase the difficulty of exact placing and synchronization, which is why two or four projectors are often preferable. While the projectors can be used in line, with the light of one lamp passing through two or more strips of developed and printed film, so that the first image goes through the second before hitting the unexposed film, the use of four rather than two projectors generally requires the use of a prism to bring the beam of light to the camera lens. This prism allows the beam from projectors 1 and 2, in line and facing the camera, to pass through. But projectors 3 and 4 are in line at right angles to this axis, and their beam has to be bent by 90° to hit the camera lens. The prism also combines the two beams (four images) into the composite recorded on the camera stock.

If the two pairs of projectors are in line, the intention is not usually a multi-image effect. In fact, it's likely that the two projectors nearer to the camera will not contain so much an image as an image-blocker, ie a mask or matte that blocks out part of the image behind it. Since the two mattes will normally be complementary, and the combined image can be seen by inspection through the camera's viewfinder, any faults, such as overlaps or gaps, should be observed at the time and, if possible, corrected on a second, third or fourth take. This is more economical and satisfactory than getting the results of multiple passes back from the lab and discovering that a whole day's work has to be redone.

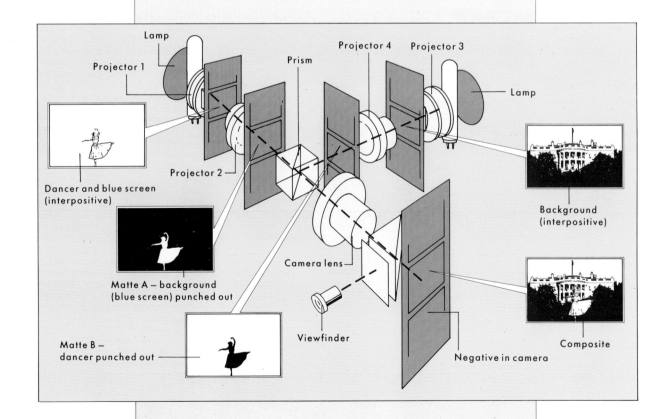

Lamp

Projector 1

Prism

Projector 4 Projector 3

Lamp

Dancer and blue screen
(interpositive)

Projector 2

Background
(interpositive)

Matte A – background
(blue screen) punched out

Camera lens

Viewfinder

Composite

Matte B –
dancer punched out

Negative in camera

36

The Optical Printer and Optical Effects

Many of the effects described in this and the next chapter depend on the optical step-printer which is a 'one-frame-at-a-time' printer, as opposed to continuous run past a light-admitting slit as used to produce duplicates ('dupes') and release prints. The step-printer is basically a camera combined with one or more projectors. Four projectors are the usual limit for practical convenience and for keeping 'in sync', that is, synchronized or in time together (*see* opposite).

Even a single projector makes possible such basic effects as running the film backwards, as in the reverse slap already mentioned in *Day for Night*. The projector projects, not onto a screen but onto another film of, usually, the same size as the projected film, eg 35mm, though there is some advantage in terms of reduced graininess in projecting from a larger to a smaller stock, such as 65mm or VistaVision to 35mm. The 1:1 ratio between projected and camera film can be varied if the projector or, more conveniently, its lens can move back and forward. In this way, part of the projected image can fill the whole frame of the camera film, or conversely the image can be reduced to fill only part of the raw film stock's rectangle. In the second case, another pass through the camera can fill the remaining space or part of it (three to six passes might be required for a multi-image effect).

RIGHT An intricate set for the ballet in *The Red Shoes* (1948) is partly a matte painting, an illusion within an illusion. The theme of both ballet (based on a Hans Christian Andersen story) and film is that the artist must choose between 'life' and 'art' — especially if she is a woman. Both the village girl and Vicky (Moira Shearer), who dances her, choose art but try to cling on to life too, a conflict that ends in disaster and death.

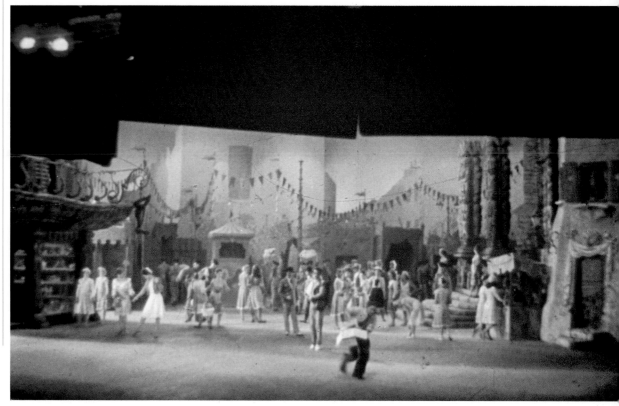

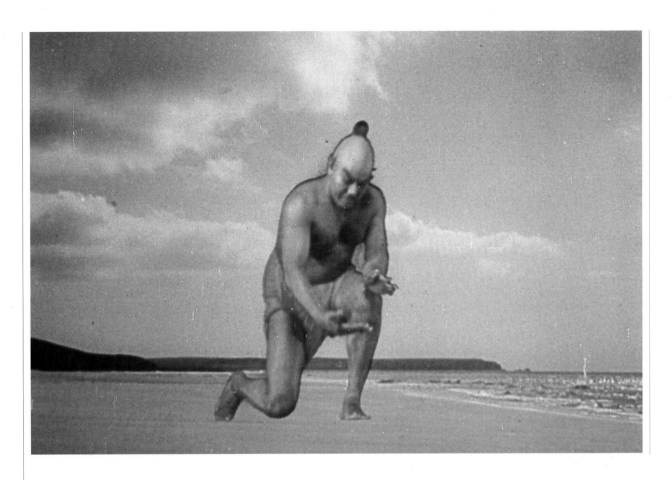

A very elementary example of the optical printer's work is the on-screen masking in *Rear Window* (1954), the kind of effect that dates back well before Hitchcock's own silent-film period to the 1890s and 1900s. In this case it represents Jeff's (James Stewart) view of the windows around and across the courtyard that has become his world since being immobilized with a broken leg. Since he looks through binoculars and a long-lens (telescopic) camera, these masks are simply a stylized binocular view and a round (monocular) shape.

At the other extreme, in the ballet called 'The Red Shoes' in *The Red Shoes* (1948), Vicki (Moira Shearer) acquires the red shoes that compel her, or the balletic character she plays, to dance to her death, fleeing the diabolical shoemaker (Leonid Massine). The shoemaker dances with her in her first excitement and then collapses and turns into a tangle of dead leaves as she tires. She stoops to pick up the leaves, then drops them as (by a cut) they transform into a knife.

This and other transformations, rendered in the beautiful Technicolor of the 1940s (which has faded far less than the colour processes of the 1950s and '60s), call on the state-of-the-art technology of the period,

ABOVE & OPPOSITE
The Djinni (Rex Ingram) captures a terrified young thief, Abu (Sabu), in *The Thief of Bagdad* (1940). The scenes of Abu and the Djinni were directed on a Cornish beach by Michael Powell. The film deservedly won Oscars for its cinematography (Georges Périnal), art direction (Vincent Korda) and effects (photographic: Lawrence Butler; sound: Jack Whitney).

which still looks very sophisticated. Perhaps this is due more to the quality of visual imagination displayed by the director, Michael Powell, and the designer, Hein Heckroth, than the technology credited to F George Dunn (special photographic effects) and D Hague (Technicolor composite photography), expert though they were. Curiously, this is the only Powell/Pressburger film to give such credits and the first Powell one to do so since the multi-directed *The Thief of Bagdad* (1940), which in fact won that year's Oscar for effects and sound. *The Red Shoes*, though nominated in several categories — it won in Art Direction/Set Decoration (Heckroth, Arthur Lawson) and Music (Brian Easdale) — was not nominated in the Effects category. Unfathomable are the ways of Hollywood.

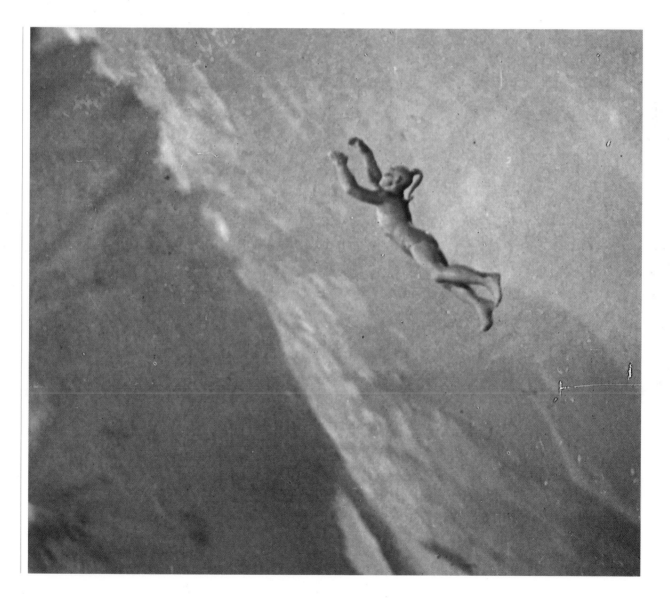

39

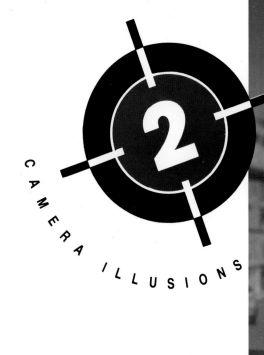

2

CAMERA ILLUSIONS

MATTES AND MATTE PAINTINGS

The broad division of SFX into optical and mechanical (or physical) does not imply a total distinction between the two: mechanical effects are frequently modified by optical means, and optical effects often rely on mechanical and electronic elements. But the effects described in this chapter depend essentially on the camera, projector and optical printer (which, as we've seen, is basically a combination of these), and the 'glass shot', or matte painting, is only a partial exception.

BELOW In the 'happy ending' of *Marnie* (1964), Mark (Sean Connery) drives away with Marnie (Tippi Hedren) and the car turns just before encountering the large painting of a ship at the end of the street. Although Hitchcock was criticized for the phony backgrounds and effects in parts of this film, he did use a real ship when it was really needed (for parts of the honeymoon cruise); and the settings and costumes are quite lavish.

A painting is an illusion in a stricter sense than a model or make-up or a stuntperson double. It tricks the eye in a different, more thorough way. Even the French expression for tricking the eye, *trompe-l'oeil,* refers in architecture to 2-D painting masquerading as 3-D architectural forms or decorations.

The familiar painted backdrop of the theatre appears also in the cinema: the notoriously unconvincing backdrop of a large ship at the end of a terraced Baltimore back street in *Marnie* (1964) is a case in point, but a tricky one. In the early scenes there, as Marnie (Tippi Hedren) comes home alone to visit her mother (Louise Latham), the line where the built set of terraced house continues as painted houses, diminishing in perspective towards the ship, is clearly made apparent by the darker lighting of the painting, directly in front of which a group of children are playing and singing. However, at the end of the film, the car driven by Mark (Sean Connery) drives right down to the end of the road, and instead of falling into the (non-existent) harbour, turns right into a previously unsuspected street or quay along its edge and disappears

THE END

LEFT The final shot of *The Birds* (1963) is an elaborate composite containing over 30 separate elements. It is also ambiguous in tone, allowing the main characters to get away from Bodega Bay, but not necessarily implying any safe or happy ending elsewhere.

from view. This sequence closely matches the final shot of *The Birds* when a car turns left in the distance and is seen no more. Is this a model shot? (It doesn't look like it.) Were there two sets, the first being regarded as unsatisfactory? (There are some odd sets in this film, including the Rutland offices, which show the bare interior of the studio, presumably passing as some sort of converted warehouse.) Who knows? Hitchcock's intentions were even more obscure than usual when he was making *Marnie*.

A notably successful example of a glass shot (*see* page 44) appears in the Powell/Pressburger version of Rumer Godden's 1938 novel, *Black Narcissus* (1947), which centred on a small group of nuns in the Indian Himalayas. Michael Powell and Emeric Pressburger had previously worked on original scripts; this was the first of four novel adaptations, of which *The Small Back Room* (1949), the only one in black and white, was paradoxically the best, though they were the supreme colour artists of British cinema in the 1940s and '50s. To the disappointment of the crew, who fancied a trip to the East, Powell decided that India would be recreated entirely in the studio. The veteran German designer Alfred Junge produced some marvellous designs for the settings, particularly the convent, a former 'house of women' or quasi-harem on the verge of a precipice, that won him an Oscar. Only the acting areas for these sets were built, the rest being painted on glass. When the renegade Sister Ruth (Kathleen Byron), a seething mass of frustrated sexuality and jealously, attempts to push Sister Clodagh

GLASS SHOTS

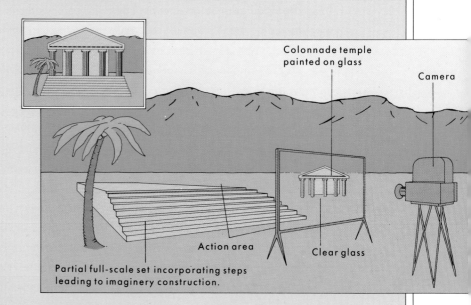

Colonnade temple painted on glass

Camera

Action area

Clear glass

Partial full-scale set incorporating steps leading to imaginery construction.

The 'glass shot' was originally painted on glass — and often still is — so that it fills only part of the frame, the rest of which is occupied by a built set and/or action. Around the end of the silent era and in the early sound days, the glass was actually in front of the camera during shooting, possibly adding storeys to a low building or giving a view of non-existent distant hills, or whatever was required. (The bell tower added to the real church on location at San Juan, California, in *Vertigo* has already been mentioned.)

The camera had to get both this and the foreground action (which in fact was further away than the glass and shot through it) into focus while creating a convincing effect — too sharp a focus on the glass painting might be counter-productive, revealing its flatness and unchanging lighting.

With the advent of rear and then front projection and more elaborate types of matte shot (eg travelling matte), the glass shot and the action might conveniently be shot in different places at different times. But the principle remains essentially the same: a mixture of 3-D reality and 2-D illusion coexisting on the 2-D plane of the film's emulsion and apparently representing some aspect of the 3-D actual world, or some more or less realistic fantasy world.

(Deborah Kerr) over the edge of the cliff and instead falls herself, we are spared the usual phony diminishing figure dropping away. There is no precipice except in the painting (though no doubt Junge could have painted the downward view if asked) and Deborah Kerr has to act shock/horror, which she is perfectly capable of doing, and does splendidly. While the film was a less personal project than *The Life and Death of Colonel Blimp* (1943) or *A Matter of Life and Death* (1946), or even the subsequent *The Red Shoes,* the intensity of Powell's personal relationships with both Kerr and Byron (not at the same time) communicates itself to the film, and its hothouse atmosphere loses nothing by the lack of wide open spaces. The slightly artificial air of the settings is entirely apt to the theme of façades maintained over emotional chasms or rushing torrents of erotic feeling. The scene where Kathleen Byron puts on bright red lipstick is far sexier than most modern bedroom scenes with thrashing limbs and hovering breasts.

Whereas traditional matte painting was oil paint on glass, acrylics are now also used, especially for the first draft (they dry quickly), though some artists consider that oils are truer in colour and prefer to use them throughout or at least finish with them. Because of more elaborate film-printing techniques and finer-grained film stocks, board or even canvas may be used instead of glass and a black or white silhouette substituted for the clear glass area — though glass still provides a uniquely flat, untextured and rigid surface.

The technical advances of recent years have made it possible for a particularly skilled artist, such as Matt Yuricich, working for instance on the final rooftop confrontation between Deckard (Harrison Ford) and Roy Batty (Rutger Hauer) in *Blade Runner,* to reduce the number of generations of film going into the composite (ie action + backgrounds) by imitating the colours of film rather than of nature (or, in this case, of the concrete jungle).

Normally, release prints are made from a duplicate ('dupe') negative, much as the pictures in this book are made from dupes of the (expensive, irreplaceable) slides borrowed from agencies. The camera negative of a feature film is far more expensive and irreplaceable (in Italy, camera negative has even been kidnapped and held for ransom). Indeed, the negative cutter nowadays gets a special credit (though it was not the case when Marilyn Monroe's mother performed this responsible task in the 1930s and '40s). The stage in between the original negative and the dupe is called an interpositive, and is on a low-contrast stock with a limited range of colours, mostly greys and greens. Yuricich (whose brother Richard, a cinematographer specializing in

ABOVE In *Black Narcissus* (1947), the main setting of a convent on the edge of a precipice in the Himalayas was largely created by matte paintings — here we see the process. According to director Michael Powell, the crew and actors were looking forward to a trip to India, then in the last days of Empire; but they eventually accepted that 'art' was as good as, or better than, 'reality'.

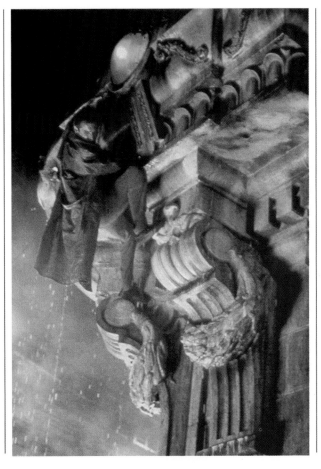

effects, originated the technique in the late 1970s) imitated the colours of this interpositive, and his work was photographed on a high-contrast dupe stock of specially fine grain.

In the shot from above of Deckard hanging from the side of the building, the painting, mostly in shades of blue and purple, represents the precipitous drop beneath his feet. The action occupies roughly the lower half of the frame and the painting fills the central area of the upper half — at the sides are some bits of built set, in miniature. During filming, directly below Harrison Ford's feet (ie above him in the frame) was a white sheet to allow space for the matte. In fact, the composite shot, which is on screen for a mere fraction of a second, was to include several other elements, including the ever-present acid rain — the creation of which (as described in fascinating detail in *Cinefantastique*, vol 12, no 5/6, 1982) was a saga in itself.

The original negative of the action shot was processed and printed (interpositive) to make a second negative (internegative) from which the positive for the matte shot was produced. Since this internegative was at the same stage as Yuricich's dupe, two generations of film had been skipped to produce a higher quality shot in which the join is much harder to detect.

While the 1970s and '80s brought new levels of technical expertise, some of the best matte paintings of all time can be seen in a 1930s production which, though having a very big budget for its day, nonetheless incorporated shrewd economies, including the avoidance of location shooting and of building sets that would be used only briefly. Several of the Georgian mansions in *Gone With the Wind* (1939), together with most of the burning buildings of Atlanta (or rather, the buildings in front of those supposed to burning in the distance) were the work of the talented matte painter Jack Cosgrove, though for montage sequences he had help from the neighbouring MGM effects department, since MGM and Selznick, the producer, were both located in Culver City. Some ingenious shots that peel away Cosgrove's rural mattes to reveal the cityscape behind even the real buildings, such as Selznick's own trademark administration building (luckily built by Thomas Ince in the Greek-classical porticoed style of Southern plantation mansions),

ABOVE In *Blade Runner* (1982), Deckard (Harrison Ford) is losing his battle with the last of the renegade replicants, Batty, and finds himself trying to escape by climbing the crumbling stonework of the Bradbury Building. Although this is not exactly the shot described in the text, the same principle applies of a painted matte background in muted colours, saving two generations (one negative, one positive) of refilming.

are shown in David Hinton's well-researched documentary, *Making of a Legend: Gone With The Wind.*

Though matte painting was and is favoured largely for economy — it reduces travel or set building or both — handcrafted painting is at times capable of effects that are beyond photography in terms of atmosphere, imagination and invention. It is not a stopgap but a proper part of the cinematic arts.

Rear projection, or back projection, started in the silent era with the projection of a still background, or photographic 'plate' (often on glass rather than celluloid), on to a translucent screen placed behind the action to form the equivalent of a theatrical backdrop or cyclorama effect. By the 1930s, when the problems of dialogue recording made it easier to bring the world into the studio rather than taking the camera to the world (whereas in the pre-sound 1920s it was fine control of lighting that favoured studio shooting), moving images — then and now called 'plates' — could be projected behind the action and foreground props or sets, provided the camera and projector were (as in the step-printer

BELOW Shooting this scene in the 1930s on location would have caused endless technical problems and have been very expensive to set up. However, the use of rear projection solves the problem. The mountainous background scene, previously shot on location, is projected onto the rear of a translucent screen placed behind the actor and the balloon. The camera, exactly synchronized with the projector, records the action.

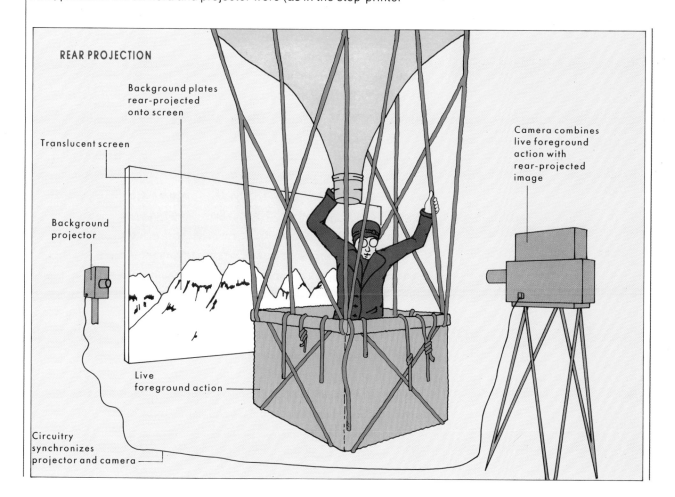

REAR PROJECTION

Background plates rear-projected onto screen

Translucent screen

Camera combines live foreground action with rear-projected image

Background projector

Live foreground action

Circuitry synchronizes projector and camera

already discussed) exactly synchronized. By 1933, the audience was already sophisticated enough to enjoy, in *The Fatal Glass of Beer,* scenes that deliberately emphasized the artificiality of the process, as when W C Fields half-heartedly drives his team of malemute dogs across the frozen Northern wastes of the Yukon, prospecting for gold — though one of the dogs is too small for its legs to reach the ground.

Since the screen is translucent, not transparent (otherwise the camera would simply photograph the projector on the other side and its beam instead of the image), the light loss could be a problem. This was the case even with black and white (monochrome), though the shallow focal planes preferred in much 1930s cinematography, sharp only on the foreground or middle ground, tolerated slightly dim and fuzzy backgrounds which were seen out of focus in the final process shot. By the early 1940s, the ifluence of Orson Welles and William Wyler as directors, together with Gregg Toland, the innovative lighting cameraman they shared with each other (and sometimes with John Ford and Howard Hawks too), made deep-focus more fashionable. The trend was encouraged by the return to location shooting in some types of thriller and war film (influenced by wartime documentary and newsreel photography) in the late 1940s.

With the advent of colour, the existing difficulty of matching light levels was further complicated by the additional problems of matching colours in saturation as well as in hue. (Brilliance is not necessarily a difficulty here, since brightness drops with distance in nature, and so less bright distant landscapes would look normal.) Where fantasy is involved, as in a film like *The Wizard of Oz* (1940), non-realistic, simple colours are acceptable, provided they add up to a coherent scheme that works within the special world of that film. Not so where an illusion of everyday reality is more important. Even in *Oz,* one is more conscious of the stylization in the opening and closing sequences, set in a (monochrome, originally sepia but now usually black and white) Kansas farm.

This may have been one, incidental, reason why black and white held on till the mid 1960s for much drama and some kinds of comedy and thriller, and has since then been revived by New York-oriented (therefore nonconformist) directors like Scorsese and Woody Allen. (The later Warhol films, not directed by Andy himself, were in colour — as were the majority of his paintings and prints, after all.)

Perhaps the most familiar example of back projection, and one in which minor imperfections are less noticeable, is the view behind, or beside or in front of, the driver and passengers in a car, or, more

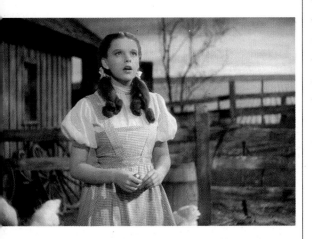

ABOVE Judy Garland, as Dorothy, sings 'Somewhere Over the Rainbow' in the opening black-and-white (originally sepia) section of *The Wizard of Oz* (1939). The stylized Kansas farmyard is already halfway between the real world of Depression America and the fantastic world of the Munchkins and the Emerald City.

infrequently, bus or train. Cars have been popular in the movies since Mack Sennett was wrecking them around 1914 in such shorts as *Lizzies of the Field* — not funny to some members of early audiences, who were trying to save up for a Ford Model T or 'tin Lizzy'. Cameras were already being mounted on cars for action scenes and cameras were mounted on cars again in the 1960s onwards, sometimes even for dialogue scenes (they could be rerecorded later, if necessary). But for decades such scenes were done in the studio: if you think of the scene between the brothers Charley (Rod Steiger) and Terry (Marlon Brando) in *On the Waterfront* (1953), as they talk in the back of a limo, the background of

BELOW The technique of back projecting the figure of an actor – originally shot on a full-scale set – onto a small screen hidden in a miniature set was both ingenious and advanced when devised by Willis O'Brien in 1932. Nowadays the same effect would almost certainly be achieved using front projection.

MINIATURES

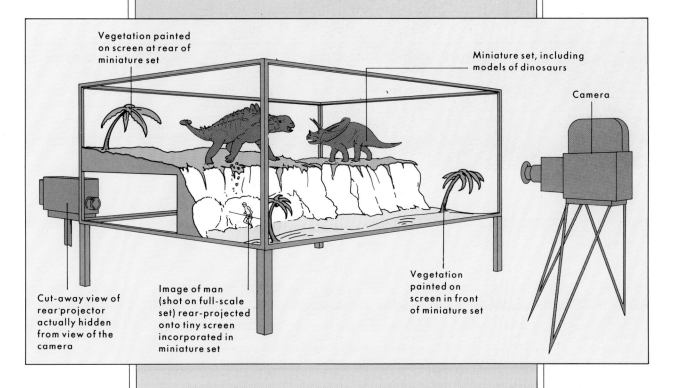

Vegetation painted on screen at rear of miniature set

Miniature set, including models of dinosaurs

Camera

Cut-away view of rear projector actually hidden from view of the camera

Image of man (shot on full-scale set) rear-projected onto tiny screen incorporated in miniature set

Vegetation painted on screen in front of miniature set

LEFT Take three girls (from screen left, Jean Peters, Maggie McNamara and Dorothy McGuire) and one (partial) car and a back-projection screen, and hey presto! Rome in *Three Coins in the Fountain* (1954). Although much of the film was shot on location — indeed, this was the whole point of what was, in effect, a glamorous travelogue — for decades automobile shots were done this way. It was easy, it was lazy, and it looked terrible.

night-time streets has to be there and be moving; but it's only partly visible (and the cars of the 1930s and '40s had small rear windows) and becomes dramatically significant only after Terry has left the car.

Sometimes, of course, the backgrounds are more important, even the main point of the ride, perhaps suggesting an atmosphere of exotic glamour. In *Three Coins in the Foundain* (1954), the Roman backgrounds are the whole point of the story, not just for the audience but also for the Romanian-born director Jean Negulesco (Romanian is the only Latin language of Eastern Europe) and, most important, for the three American girls (Dorothy McGuire, Jean Peters, and Maggie McNamara) who throw coins in the massively theatrical Trevi fountain in the hope of romance rather than simply of returning to Rome — which, indeed, gave its very name to romance. The views of Rome as they travel about by car are the objective form of their longings, before their more practical embodiment in such continental charmers as Rossano Brazzi and Louis Jourdan.

Hitchcock's fondness for artifice, and latterly for extended European holidays combined with location filming, met with a setback in *Torn*

Curtain (1966), a spy story that was meant to comment on the Burgess and Maclean scandal of the early 1950s, but went wrong in scripting and casting. This was a pity, since Hitchcock had the assistance of no less than Hein Heckroth as production designer and fellow-cockney expatriate Albert Whitlock (who had also worked on *The Birds* and *Marnie*) to do the matte paintings — he created most of the art gallery that figures in one sequence as a meeting place.

Though Hitchcock himself toured the locations in Denmark, East Germany and Sweden, he settled for filming at the Universal lot in the San Fernando valley. Some exteriors were subcontracted to a German crew, presumably within the nationalized, party-controlled and uncreative East German film industry, mainly for economy — the stars had been too expensive and corners were cut elsewhere. Hitchcock regretted the decision when he found that the plates for the extended sequence involving two buses travelling between Leipzig and East Berlin were unsatisfactory. The 'false' bus, used for escaping refugees, is carrying Michael (Paul Newman) and Sarah (Julie Andrews), American scientists on the run from the security police, to the comparative safety of East Berlin; it has to keep a few minutes ahead of the real, scheduled bus, so in fact most of the shots out of the bus windows concentrate mainly on the distance between the two buses, gradually diminishing and so raising suspicion. The plates, therefore, though clearly not quite right in colour, are not that noticeable in normal viewing. Hitchcock should have worried more about some of the dull and static sequences earlier in the film, after which the bus chase comes as something of a lift, even if overextended. The film recovers only in the brilliantly Hitchcockian scene when Michael, in a crowded theatre, pretends to believe that the blowing, twisting red ribbons behind a vindictive ballerina (Tamara Toumanova) really are the fire that they represent, and panics the whole crowd in order to escape from the secret police. The close-up of the ribbons, preceded by a short, almost subliminal zoom, nearly persuades us too that the fire is real, a totally unclassifiable special effect.

FRONT PROJECTION

The limitations of rear projection led to the development of front projection, which has its own limitations but usually looks better on-screen than rear projection, sometimes to the point of being almost impossible for the non-expert to detect. Front projection ingeniously

BELOW In *Torn Curtain* (1966), Michael (Paul Newman) and Sarah (Julie Andrews), American scientists on the run in East Germany, take a special bus from Leipzig to Berlin, a bus for escapers and their helpers. Hitchcock had the 'plates' (background shots for rear projection) made by East German cameramen employed by the state industry and subsequently wished he had not — but most viewers are untroubled by the technical shortcomings.

BOTTOM In *Torn Curtain* (1966), Michael and Sarah are recognized at a ballet they attend in East Berlin. Michael, by pretending the false fire in the scenery (composed of red ribbons and a fan) is real, causes panic in the audience and the two get away in the ensuing confusion. Here, unusually, the effect is meant to be unconvincing to the movie audience and believable only to the ballet audience, who can not see the close-up we get.

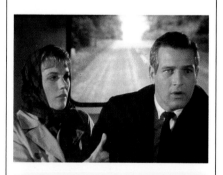

FRONT PROJECTION

For front projection, the projector is still threaded up reversing left and right, as in rear projection (it is put in the 'wrong' way round in order to come out correct in the final composite); but instead of being behind a translucent screen, it is in front of, and to one side of, a glass-beaded screen which reflects nearly 100 per cent of the light falling on it but only in the direction from which it came. Though the projector is at 90° to the camera-screen axis, and its beam is therefore initially parallel to the plane of the screen, passing in front of the actors in the foreground, this beam is deflected by a half-silvered mirror at an angle of 45° to the beam. This semi-transparent mirror is coated at the front (unlike normal mirrors, coated behind the glass) with a very thin layer of aluminium — silver tarnishes too easily. Alternatively, the layer of aluminium may be spattered on, so that tiny reflective spots of metal are interspersed with tiny transparent gaps. So, although it reflects the beam, the camera can photograph both the action and the reflection from the screen through the mirror. Though the mirror reflects the still or moving image from the projector on to the actors and any foreground props or sets as well as on to the screen, the level of illumination of the image is much less than that on the actors, so the camera records only that part of the image reflected from the screen. Equally important, the bodies of the actors conceal their own shadows on the screen, provided they don't move too fast and the camera stands still, or at least does not move sideways. This restriction can be irksome at times, in which case rear projection – otherwise largely superseded – comes into play.

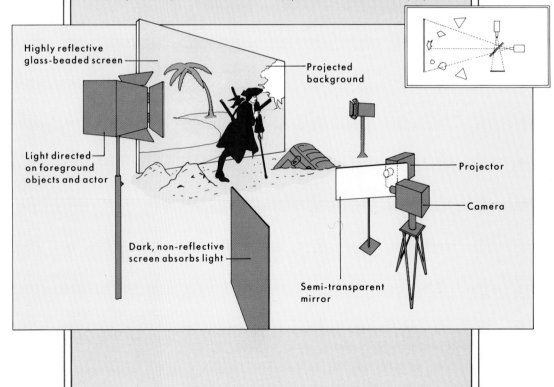

Highly reflective
glass-beaded screen

Projected
background

Light directed
on foreground
objects and actor

Projector

Camera

Dark, non-reflective
screen absorbs light

Semi-transparent
mirror

combined existing technology (the half-silvered mirror, used by magicians) with new (the glass-beaded screen). Stanley Kubrick's *2001: A Space Odyssey* (1968), produced in England but using both British and American effects specialists, was probably the first film to make extensive, and widely publicized, use of front projection. The opening scenes are particularly memorable: primitive apes (men in monkey suits) struggle against a rival tribe of predators in front of an open, harsh background (projected) until one of them 'invents' the first weapon in striking an enemy with a large bone, which, thrown up spiralling into the air, 'becomes' in the next shot a spacecraft four million years on in time.

At George Lucas's Industrial Light & Magic (ILM), the northern Californian effects factory, according to ex-general manager Tom Smith, front projection was used in conjunction with matte painting on glass to project the foreground action, rather than the background, on to a gap left in the matte painting and backed by a Scotchlite screen. This could, though, sometimes give rise to colour discrepancies between action and painting, particularly when the film appeared on TV. However, he got better results in his own TV film, *The Ewok Adventure* (aka *Caravan of Courage,* 1984), which he produced for Lucas, by shooting some action sequences with most of the picture area on the

BELOW Africa comes to Borehamwood, England, for the opening scenes of *2001: A Space Odyssey* (1968), set in remote prehistory, four million years ago. The apes were men in suits; the front-projection plates were large transparencies made in southwest Africa; and the successful use of this technique marked a step forward beyond the limits of back projection. As a result of more recent technical advances, it is possible to front-project in front of as well as behind the actors, so that they are the meat in a three-ply visual sandwich.

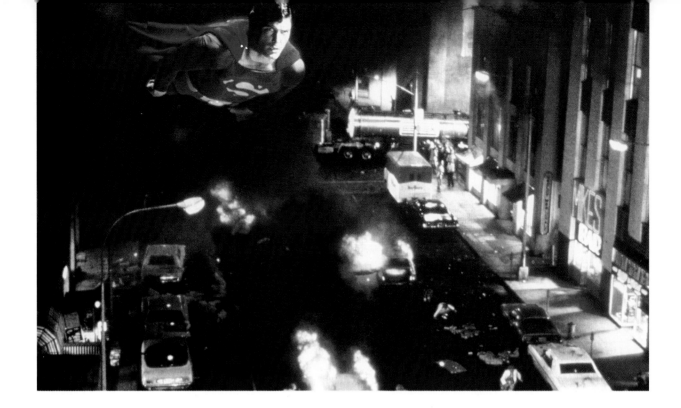

negative blocked off, then — working from a test strip just before the main action — matching the matte painting to the unexposed area and finally compositing action and painting together. The drawback is that this method allows very little latitude for error or changes of plan, but it does give a very realistic effect with excellent colour matching.

ZOPTIC PROCESS

Front projection is combined with a double zoom effect for the so-called Zoptic process (patented by Yugoslavian-born British effects man Zoran Perisic), which enabled Superman to fly convincingly in close shots. Wirework and other effects involving stuntmen were also used. Richad Donner, who directed *Superman, the Movie* (1978) and started *Superman II* (1981) before being replaced by Richard Lester, says that travelling mattes were little used.

The Zoptic process is quite simple in principle, but is also very flexible and capable of more elaborate variations, as occurred in *Superman*. Basically, it depends on fitting both camera and projector with zoom lenses, exactly synchronized in their movements, in addition to the normal synchronization of the shutters that govern exposure and projection of the image respectively of camera and shutter in simple front or rear projection.

When the projector has a fixed lens, the size of the image on the reflective screen is constant. With a zoom, however, it is larger when

ABOVE Superman (Christopher Reeve) flies over the concrete canyons of Metropolis in *Superman II* (1981), thanks not only to the wires or pole supporting him but also to the Zoptic process patented by Zoran Perisic. This depends basically on fitting a front-projection set-up and the camera with synchronized zoom lenses, so that the background changes rapidly while the actor remains still.

54

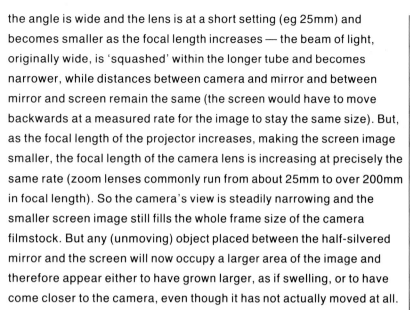

the angle is wide and the lens is at a short setting (eg 25mm) and becomes smaller as the focal length increases — the beam of light, originally wide, is 'squashed' within the longer tube and becomes narrower, while distances between camera and mirror and between mirror and screen remain the same (the screen would have to move backwards at a measured rate for the image to stay the same size). But, as the focal length of the projector increases, making the screen image smaller, the focal length of the camera lens is increasing at precisely the same rate (zoom lenses commonly run from about 25mm to over 200mm in focal length). So the camera's view is steadily narrowing and the smaller screen image still fills the whole frame size of the camera filmstock. But any (unmoving) object placed between the half-silvered mirror and the screen will now occupy a larger area of the image and therefore appear either to have grown larger, as if swelling, or to have come closer to the camera, even though it has not actually moved at all.

If the projected image is a still one, the illusion of movement may be counteracted by the lack of parallax, as mentioned before, but only if the background appears fairly near and with strongly marked pespective. If it appears relatively flat and equidistant, or quite far away, the lack of parallax may not be a problem at all. Equally, the projected image may itself incorporate movement, especially if shot from a fast-moving source (a helicopter, aeroplane or whatever), in which case even the nearer parts of the background will be fairly distant.

As an additional sophistication in *Superman,* both camera and projector were slung from rigs that allowed them to be moved too. The complexity of variables thus introduced is almost literally dizzying, and either a lot of complicated sums or (more likely) much trial and error, rehearsing with stand-ins, must have been done. Superman (Christopher Reeve) himself was sometimes hung by wires (the disadvantage of which is that they might have to be matted out frame by frame by hand) or supported on a hydraulic arm that came out of the screen at 90° and which, like his shadow, was hidden by his body.

TRAVELLING MATTES

As we have seen, a matte is basically a mask (for example, a black card, or a painting on glass left partially clear) that blacks off a part of the frame or, usually, part of a whole succession of frames. The part of the frame that is covered, or protected from light, remains unexposed. On the second run of the film through the camera or optical printer, the

BELOW In *Star Wars* (1977), Ben Obi-Wan Kenobi (Alec Guinness), an old Jedi knight, fights a duel to the death with his renegade former pupil, Darth Vader (David Prowse). Their laser swords were photographed using front-projection material on the blades, However, this material is highly directional and did not show up well, so the brightness was enhanced by frame-by-frame rotoscoping.

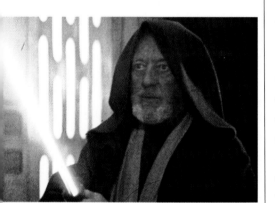

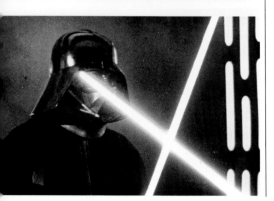

already exposed part is covered and the previously unexposed portion is now exposed to create a composite image consisting of two, or more, previously separate elements. If the mattes are fixed, the relation between the various elements is consistent. This is a severe restriction which the travelling matte overcomes.

A further sophistication, though in fact historically a return to basics, is rotoscoping. The same method in principle was used to convert Snow White and her Prince from photographic images of actors to animated characters. Instead of being produced photographically, the mattes are made frame by frame, by projecting the image and tracing it by hand. Like all forms of animation, this is time-consuming, labour-intensive and, therefore, expensive. So it is used mainly for brief shots or parts of shots, or for very special effects — perhaps the most familiar being the laser swords in the *Star Wars* series.

Hitchcock's *The Birds* made extensive use of a variety of effects, including matte painting, travelling mattes and rotoscoping. A notable example occurs just after the fire has started in a gasoline station at Bodega Bay, near the harbour. An aerial view of the scene, from high above the town, includes gulls dropping into the shot from each side — clearly an 'impossible' shot, virtually from a gull's-eye point of view (birds would not fly so close under a noisy helicopter). Though some of the exteriors for the film were shot on location in the real Bodega Bay, north of San Franciso, and neighbouring hamlets, the town as seen in the overhead shot does not actually exist. It was an Albert Whitlock matte painting, into which a backlot fire was inserted, filmed from a hill overlooking the Universal car park. The gulls were filmed from a clifftop on the island of Santa Cruz, west of Los Angeles, and rotoscoped into the shot (according to *Cinefantastique,* Vol 10 no 2, 1980). Making the mattes for this alone took two artists three months, for a shot lasting less than 20 seconds.

ABOVE The initial slowness and then suddenness with which the birds gather and finally attack is one of the most effective surprise devices in *The Birds* (1963). The mixture of real birds and dummies (as here) is often supplemented by animation in the action sequences.

TRAVELLING MATTE

What 'travels' in a travelling matte is the area that is blocked off. Let's take the imaginary example of a human figure in front of an exterior background, a dancer performing in front of the White House. Shooting this on location would pose difficulties of various sorts. It could be faked by rear projection or front projection: but the first would be quite obviously phony, unless lit with uncommon skill, and the second would probably be restricting in terms of movement — certainly the camera could not track sideways. So the dancer is filmed against a plain background, generally a blue screen, since this contrasts well with her flesh tones. The costume designer would therefore exclude blue from his/her range of colours. Two black-and-white strips are then prepared: the 'male' matte is clear, with the figure of the dancer silhouetted in black; the 'female' matte is predominantly black, with only the silhouetted figure clear. The foreground image, the dancer, is bipacked with this female matte and run through the printer to be photographed on a negative (the image by this time being in positive form). The negative, containing the latent image of the figure but otherwise unexposed, is not yet developed; instead it is run through the printer again, this time bipacked with the male matte and the positive of the background, the White House. The previously unexposed portion of the negative will now contain images of this background, while the previously exposed portion, protected by the matte, receives no more light and is unaffected by the second run. On development, the negative and subsequent positive reveal a composite image of the dancer performing in the street.

In practice, the photographic process is usually much more complicated and involves separate runs with the red, green and blue separation positives; that is, a minimum of six, to be multiplied in turn by the number of mattes (if several rather than one are involved – figures up in the thirties are not uncommon). In practice also, matte lines may mark the joins too visibly.

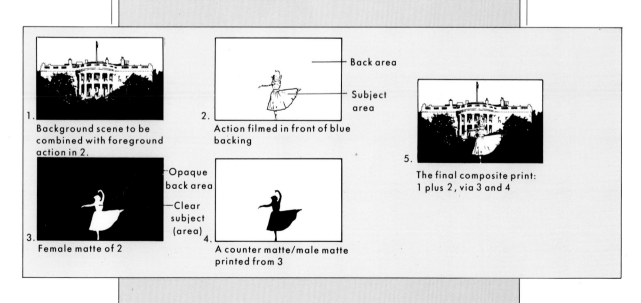

1. Background scene to be combined with foreground action in 2.

2. Action filmed in front of blue backing
— Back area
— Subject area

3. Female matte of 2
— Opaque back area
— Clear subject (area)

4. A counter matte/male matte printed from 3

5. The final composite print: 1 plus 2, via 3 and 4

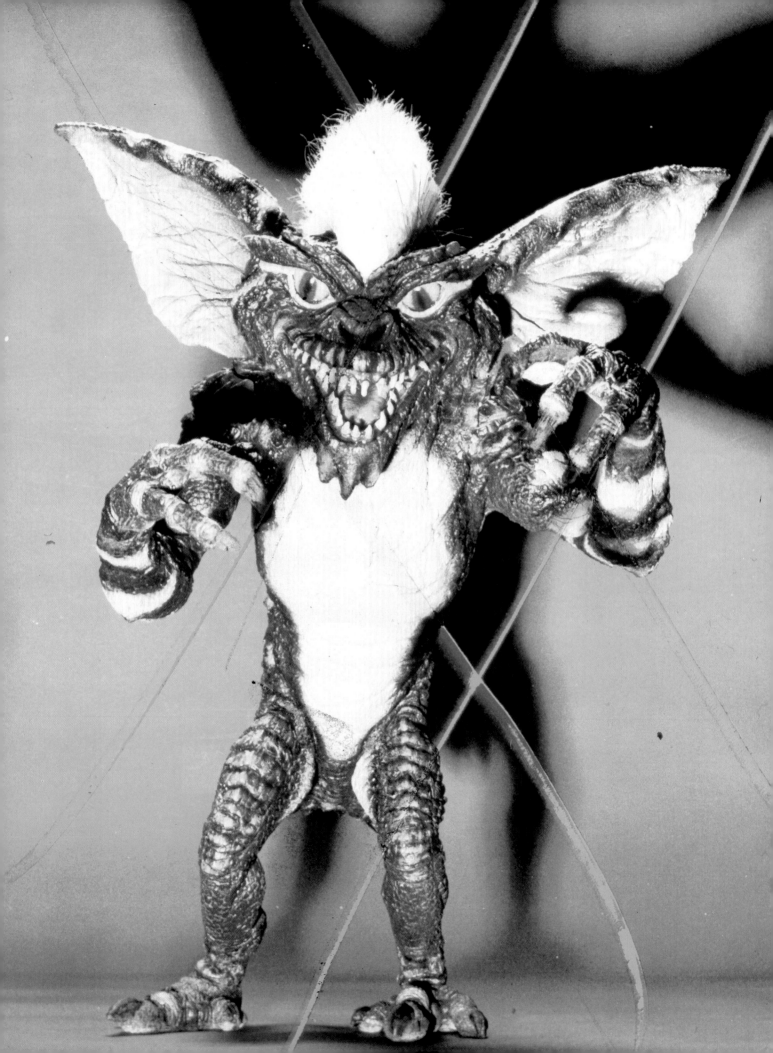

3

MAKING MODELS

This chapter deals mainly with optical (or visual) effects that involve construction in three dimensions, a stage beyond matte painting, and therefore a step nearer to physical, or mechanical, effects, which mostly tend to involve live-action shooting on set or location. But the distinction between optical and physical becomes hazy where, for example, full-size models are involved (physical or make-up) but often doubled with miniature versions (optical) for stop-motion or other effects. Indeed, animation in the strict stop-motion sense begins to cross over with mechanical or electronic animation shot as, or with, live action, so no sharp distinction is made here.

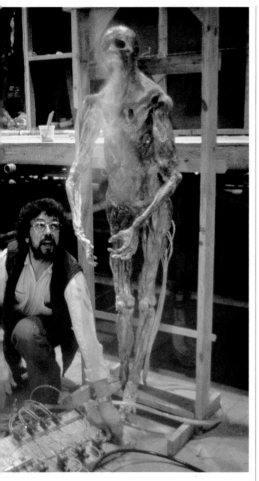

The next chapter, however, discusses physical effects in the narrower sense of the elements, especially fire and explosions, wirework, falls through glass etc. It is this area, especially in its safety aspects, that is the most important responsibility of the physical effects supervisor, whose work often ends where that of the optical effects supervisor is just really beginning. Since space permits no separate treatment of stunts and stunt artists, their work will be alluded to there and in the last section of this chapter, which concerns special make-ups and costumes — though in practice this may require not just stunt people but also the stars or extras. Sometimes, as in George A Romero's zombie pictures, not only are nonprofessional actors used on special effects but sometimes even professional critics and writers. The Academy, incidentally, includes both optical and mechanical effects under 'visual effects', as opposed simply to *sound* effects.

The types of technician, or indeed artist, that work in this area of optical effects are not so much special sorts of cameraman (like the supervisor) as special kinds of set designer/builder/decorator, modelmaker, even costumier (for miniatures or mannikins, for example). Their mechanical and electronic, even architectural, skills are in making things, in metal or plastic or wood or fabric, rather than in manipulating strips of film. For this reason, this chapter also includes full-scale models of monsters and other odd creatures; at the level of design there is often no difference at all, though there may well be when it comes to turning design into physical form.

ARCHITECTURAL MINIATURES AND WORKING MODELS

For films that need unusual cityscapes, especially those set in the future or in special situations (such as extensive destruction), miniatures must be made if matte paintings are not sufficiently 3-D and convincing, or do

not permit the required camera movement. Quite often they have to be compatible, however, with paintings or with full-size sets or even with location shots. Movie magic can be heavy in its demands.

The US-based British director Ridley Scott is essentially more a scenic artist than a storyteller, concerned with the look, with atmosphere, with densely textured visuals — as befits his art college background. His first American-made film was *Blade Runner*. (In LA he had to get used to not being allowed to operate the camera himself. Like the great Bengali director Satyajit Ray, he is by preference a hands-on, eyes-on film-maker. The two directors share, not coincidentally, a similar art background.) *Blade Runner* is an ambiguous, even confused, film, partially at odds with its source novel by Philip K Dick (remarkably entitled *Do Androids Dream of Electric Sheep?*). For instance, Dick perceived his androids as inhuman whereas Scott admired them as superhuman, and both views are represented in the film. With its last-

ABOVE Much of *Blade Runner* (1982) is a neon light show, depicting a future electric world full of delusive promise — not at all unlike the consumer carnival of today's shopping malls, in fact. The violent killing by Deckard of the snake woman, Zhora (Joanna Cassidy), briefly disrupts the show as she crashes through pane after pane of 'plate glass' (probably pre-broken plastic, in fact).

minute cop-out ending, it is for Professor Robin Wood an impressive failure, an 'incoherent text'. As an instance of incoherence, frequently commented on by critics of the film, Rachael (Sean Young), the beautiful replicant/android that the blade runner/bounty hunter Deckard (Harrison Ford) falls in love with, cannot 'become' virtually human at the end without violating the rules of the genre and the story's own premise. Yet it came a startling 7th in the top ten of the London *Time Out* readers' poll of 1989, whereas *Star Wars* (57th) and *ET* (72nd) were outside the top 50.

For Scott the design of the film rather than its storyline was the real statement and he refused to philosophize about its meaning at the time of *Blade Runner's* release, and quick demise (it was subsequently resurrected as a cult movie and video hit). The elements of that design include the city itself (a New Yorkified Los Angeles) and its industrial hinterland — an urban area at once crowded and decaying, choked with people and factories at its vast centre, yet nearly empty in its sprawling, rotting suburbs. All the enterprising, healthy people have left for other planets on which the replicants are slaves and soldiers (they are not wanted or permitted on Earth, with the doubtful exception of Rachael). For instance, Tyrell's employees, who it seems are human, are all old or

BELOW In the opening sequence of *Blade Runner* (1982), the 'spinners' (flying cars) speed over the industrial hinterland of post-nuclear Los Angeles in AD 2019, like fireflies over a garbage heap. The model cars were each separately animated (probably using the same model several times) for motion and then matted over the large table-top setting.

ill. Even J F Sebastian (William Sanderson), a genetic designer of the replicants, suffers from an unspecified disease that makes him prematurely aged (the postnuclear elements of the novel are eliminated in the screenplay). Living alone in a big, old apartment building, Sebastian makes living toys for company — played by small people, some further reduced optically. Not

surprisingly, he falls for the doll-like punk, Pris, who later masquerades as a mannikin to elude and then surprise Deckard, whom she nearly kills before he finally 'retires' her. Pris and the leader of the group, Roy Batty (Rutger Hauer), gratuitously kill the sympathetic Sebastian and, more understandably (indeed, Oedipally), Dr Tyrell. Yet Batty ultimately spares Deckard, whom he has defeated in a rooftop battle, because his own four-year term of life is used up. Hence he no longer has anything to fear from a blade runner or any logical reason to kill him. Deckard, somewhat sentimentally, interprets this as a magnanimous gesture

ABOVE The culminating buildings of 'Ridleyville' in Ridley Scott's *Blade Runner* (1982) are the twin pyramids of the Tyrell Corporation, manufacturer of robots/ androids / replicants. Only one principal model, or rather three-quarters of one, was constructed and then optically doubled. But a more detailed model of part of the structure was also needed. The thousands of tiny lights depended on fibre optics to transmit their light.

RIGHT The basic street set for *Blade Runner* (1982) was a revamped version of the old Warner New York street set, originally built in the 1930s. The addition of neon signs, oriental extras and constant rain (mostly matted on) transformed it into an alarming vision of the future, related to our present and past by 'retro-fitting', the concept of adapting old structures to new purposes by a make-do-and-mend refitting rather than radical modernization or re-placements.

indicating reverence for life, since he by now wants to believe that replicants are as good as (in practice, better than) actual humans.

The city, then, is a complex creation and at street level is a revamping of the old New York street set at Warner Bros into a sort of cosmopolitan Chinatown. A few real exterior locations in LA were also used, suitably decorated or post-matted, usually both. This downtown area was dubbed 'Ridleyville' by the crew. The whole city centre and industrial areas, when seen as a vast cityscape from the air in the film's opening shots, was 'Ridley's Inferno', and actually consisted of three tabletop models, each 6 × 13 feet (1.8 × 4m), placed side by side to give an area 18 feet (5.5m) wide and 13 feet (4m) deep. The buildings were made of plastic and glass on a plexiglass base, detailed at the front but merely silhouettes further back. The ultimate refinement, according to *Cinefantastique* vol 12, no 5/6 (1982), was that no fewer than 2000 light sources, dyed in various tints of red, orange and yellow, were incorporated in the model.

This is in keeping with the film's whole style: despite all the elaborate hardware, it is a light-show, shot mostly at night. Typical of the electric effects are the advertising blimp — Scott wanted it to look like his memories from earliest childhood of wartime barrage balloons — and the many neon signs, particularly the giant billboard screen showing an oriental girl. The signs are real neon, mostly constructed, but some

BELOW & OPPOSITE
Known mainly as an art director/set decorator (*Alien, Star Wars*), Roger Christian, or his producer, won an Oscar with his second short film, *The Dollar Bottom* (1981), and made his feature debut with *The Sender* (1982), unreleased in Britain except on video. It concerns a suicidal, telepathic young man (Zeljko Ivanek, on bed), whose disturbing visions upset a psychiatric hospital. Here we see a dummy scene being set up and the on-screen effect.

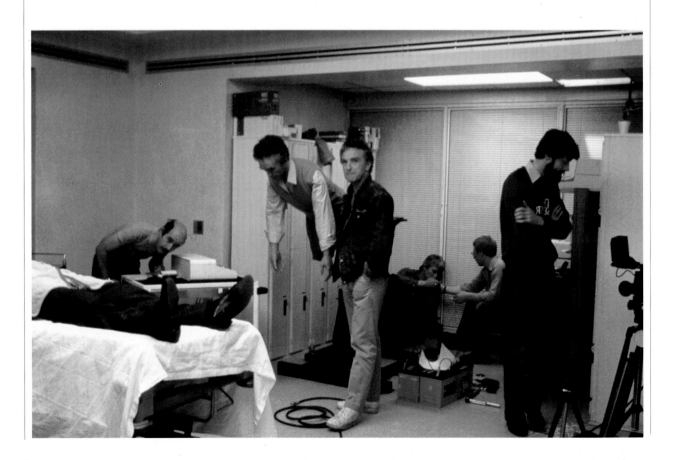

borrowed; however, the ads on the blimp are simply projected from 35mm on a second camera pass. (Incidentally, optical effects throughout were photographed on 65mm film stock for maximum quality.)

The most detailed miniature building was the pyramid headquarters of the Tyrell Corporation, where the manufacture of the replicants as well as the administration of the business and the research takes place. This had to be built in two sizes — many models in this and other films have to be built in several sizes, often three or four, and sometimes up to whole or partial full-size, for various kinds of shot or effect. Again basically plastic and glass, with painted and sculpted detail, the full (actually only three-sided) model was 9 feet (2.75m) at the base and 2½ feet (75cm) high, to represent a building some 1.7 miles (2.75km) wide and 2500 feet (750m) high, approaching 200 storeys in the middle (this compares with the 110-storey twin blocks of the World Trade Centre in lower Mahattan) — the Tyrell HQ is also doubled but only optically. The larger partial model, approximately four times the scale of the full one, was 4 feet (1.2m) high and 5 feet (1.5m) wide, with working elevators on the outside and a couple of tiny rooms built inside, as well as a landing bay for Spinners (flying cars).

The Spinners were built full-size in various forms: one in aluminium for 'flying' on wires, one in sections for interiors, two drivable in the streets. In addition, four sizes of model were made, ranging from 1 inch

(2.5cm) on the Tyrell roof to 45 inches (1.1m). The last of these included
two 18-inch (45 cm) puppets of Deckard and Gaff. The flying shots were
filmed in a special 'smoke room' at the studios of Entertainment Effects
Group (EEG), then Douglas Trumbull's company (now Boss, run by
Richard Edlund). (Other major special effects companies include
Lucas's ILM, John Dykstra's Apogee, and, on the East Coast,
R/Greenberg, much employed by Woody Allen.) The purpose of filming
through oily smoke was to give texture, and cameras were motion-
controlled by computer. This means that movements can be exactly
repeated for matte purposes — in this case, camera movements, since
it is easier to have the models stand still and move the camera on
special tracks to create apparent movements. In other films, for
example *Dragonslayer* (1981), motion control means moving the model
by computer-controlled electronic motors, while the camera stands still.

LOST
IN SPACE

For some two decades, from the solemnity of *2001: A Space Odyssey* to the broad spoof of *Spaceballs* (1987) and the engagingly camp whimsy of *Earth Girls Are Easy* (1988), space movies have set the pace for the development of special effects. With a few exceptions — notably *Forbidden Planet* (1956) and possibly *This Island Earth* (1955) — the space movies of the 1950s were quite low-tech and cheaply budgeted. *Plan 9 From Outer Space* (1956) with its paper plates for spaceships provides a notoriously extreme example.

Clearly the realities of space flight from 1957 on (manned, from 1961) made fantasy outdated unless it could visually match or outdistance such scientific advances. (In Peter Hyams' *Capricorn One* (1977), an aborted space mission to Mars is covered up by presenting a studio mock-up to the TV public as the real thing.) The 1960s were therefore low on space sci-fi until *2001* gave a new start to the genre. The

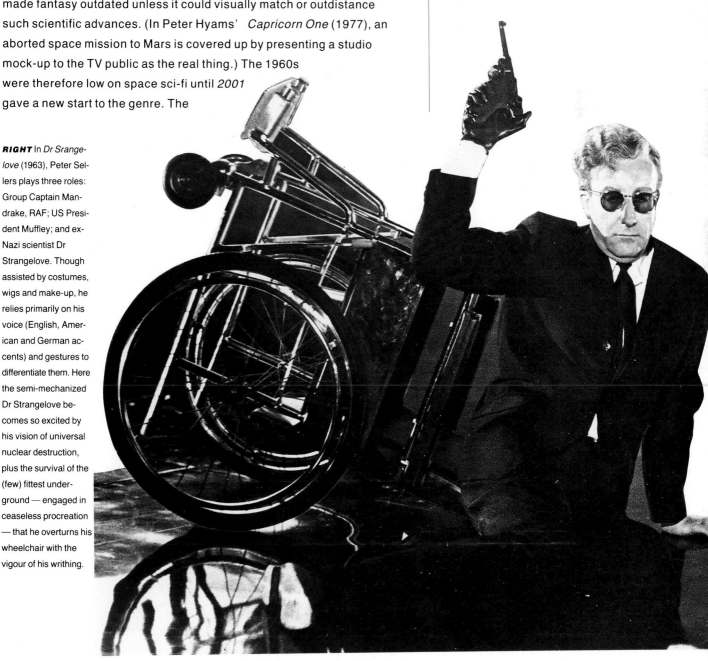

RIGHT In *Dr Srangelove* (1963), Peter Sellers plays three roles: Group Captain Mandrake, RAF; US President Muffley; and ex-Nazi scientist Dr Strangelove. Though assisted by costumes, wigs and make-up, he relies primarily on his voice (English, American and German accents) and gestures to differentiate them. Here the semi-mechanized Dr Strangelove becomes so excited by his vision of universal nuclear destruction, plus the survival of the (few) fittest underground — engaged in ceaseless procreation — that he overturns his wheelchair with the vigour of his writhing.

impressive hardware, the (rather primitive) motion-control techniques, and the startling light effects made it the biggest single breakthrough. The next was *Star Wars,* made in 1977. Whereas its basically (and intentionally) puerile story was a throwback to the serials of the 1930s and '40s, the effects were already a springboard to the 1980s, leading to the creation of ILM (Lucas's special effects company) and its proliferating offshoots.

In *2001* Kubrick was aiming at state-of-the-art realism for most of the film; then he launched off into slightly obscure fantasy in the fourth and last section, 'Jupiter and Beyond Infinity'. There is a roughly similar development in *2010,* so the pattern may derive in part from Clarke, who has presumably imbibed some elements of oriental mysticism from his long sojourn in Ceylon.

However, a tension between realism and fantasy marked Kubrick's career almost from the start, in *Killer's Kiss* (1955) and his little masterpiece of narrative complexity and lucidity, *The Killing* (1956). It

ABOVE A small spacecraft approaches the Death Star in *Star Wars* (1977). The models could be built small because the computer-controlled camera movements were exactly repeatable, giving precise control in making composite shots. Here, there are only three elements, though five or six were not uncommon: the Death Star; the spacecraft — both shot against blue screen; and the star field background, lit from behind.

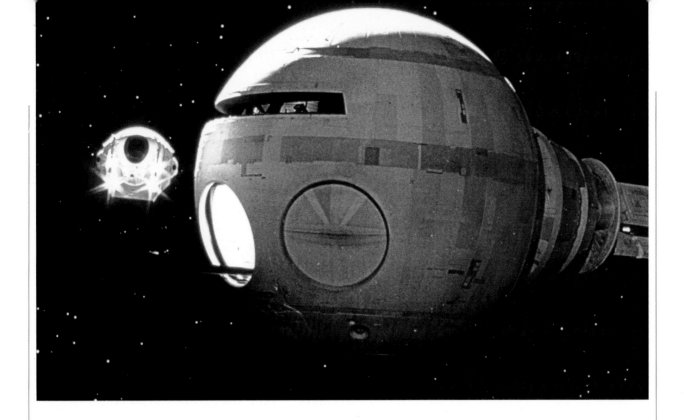

was certainly overt in *Dr Strangelove or How I Learned to Stop Worrying and Love the Bomb* (1964), with its surrealistic emphasis on machinery (a Coke machine, a wheelchair, telephones, radios, computers, aeroplanes, bombs), culminating in the semi-mechanical yet sex-obsessed figure of Dr Strangelove (Peter Sellers) himself, whose rebellious mechanical arm keeps rising in a gesture at once phallic and fascist. The swift yet controlled pace of *The Killing* had slowed down to accommodate this more meditative, talkative approach. So the rather heavy, stately movements of *2001: A Space Odyssey* to which the effects team of Kubrick himself, Wally Veevers, Douglas Trumbull, Con Pederson and Tom Howard were for the most part limited — except in the 'Stargate' section — by their simple, mechanical system (no electronics, no computer for motion control or graphics) were apt enough and perhaps fast enough.

Yet the tension between realism and fantasy already showed signs of deteriorating into mere proximity, not pulling against each other interestingly but merely being slapped down side by side — or end to end. This tendency reached its nadir in *The Shining,* but *Full Metal Jacket* represents a partial recovery, particularly in the brilliantly stylized choreography of the opening section in the training camp. In any case, *2001* marks a turning point both in Kubrick's own career — it was, indeed, his first colour film, apart from the epic *Spartacus* (1960), an emergency project in which he replaced Anthony Mann at short notice — and in science-fiction movies.

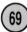

69

The deployment of a relatively big budget and the use of a really big screen (Cinerama in major cities, Super Panavision 70 where projection facilities were available), together with a show of 'serious' ideas comparable to printed sci-fi, raised the status of the whole genre, and it has never since sunk back to the level of, say, stalk-and-slash movies in critical regard. It has even become parodiable, always a sign of growing respectability. Though Mel Brooks's *Spaceballs* is principally a take-off of *Star Wars,* its opening march-past shot of an apparently endless spaceship, ever so slowly passing the camera, all lumps, bumps and 'functional' excrescences, could just as easily be harking back to *2001.*

However, the big difference between *2001* and the *Star Wars* trilogy is the multiplicity of *kinds* of effects in the later films: including miniatures, models, animation, matte painting and all (except the paintings) constantly and usually rapidly moving. The *Star Wars* trilogy curiously points two contradictory ways, both realized in the 1980s. In content it was a retreat from the comparatively adult concerns of Hollywood films in 1970-75 — including George Lucas's acute and witty portrayal of adolescence from a nostalgically adult viewpoint in *American Graffiti* (1973). But in style and technique it denoted a big

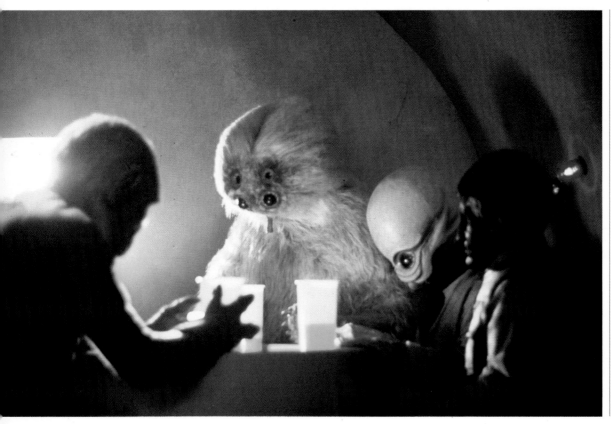

LEFT With drinking companions like these, imbibing what looks like meths, a Western-style bar brawl is practically inevitable — they come from places much further apart than Texas and Kansas, and appear more antagonistic too. One of the humorous genre references in *Star Wars* (1977), illustrating why the Lucas-Spielberg generation were long known as 'movie brats'. (Rick Baker is among the make-up artists credited on *Star Wars,* so he possibly had a hand in creating these uglies.)

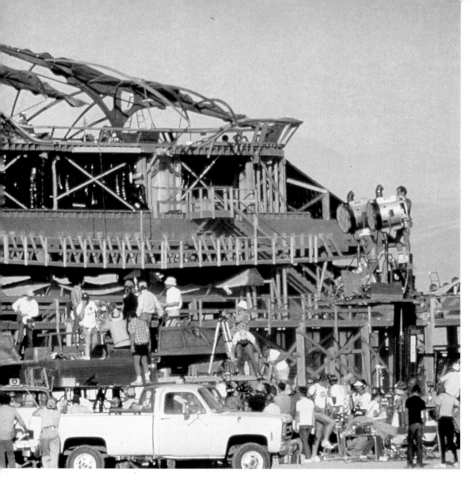

advance, notably in terms of realism; this involved such elements as exact motion control, detail in modelling, quality in matte printing, and inventiveness in the creation of robots, monsters etc.

Motion control was required in order to ensure that a whole variety of models, photographed separately against blue screen, could be exactly slotted together in composite shots to create fast dogfights between space vehicles, for instance. John Dykstra, with Richard Edlund and others, was able to set up a camera rig that moved very precisely in metal tracks, with the camera on an arm that could move up and down, while the camera itself could pan from

ABOVE This ship of the desert in *Return of the Jedi* (1983) was designed by Ralph McQuarrie, and is the setting for the first big action sequence, the rescue of Han Solo by Luke Skywalker (Mark Hamill) and Princess Leia. Whereas *Star Wars* (1977) had been quite low-budget, *Return*, at $32.6 million, was fairly lavish though not extravagant — and with rentals of £168 million, who's counting?

side to side or tilt up and down or any combination or roll over to the side and also change focus as needed. All these movements, initially hands-on though the computer control system, were stored on memory and therefore exactly repeatable.

The fine detail in modelling meant that smaller, less cumbersome spacecraft, for example, could look large and convincing on film, as could some of the weirder land vehicles. The matte paintings, limited in number, had to look good and 3-D on a fairly large scale — and they did. The robots and monsters, eclectically inspired by diverse sources (Fritz Lang to the Muppets, it has jokingly been claimed), added a new dimension to their derivations — often wit, visual and verbal. In *Return of the Jedi* (1983), for instance, a new twist was added when the low-tech Ewoks defeated the sophisticated weaponry of the Empire. However, a touch of decadence appeared to have set in by then, in that the tough space bar of *Star Wars* (universally recognized as a genre reference to saloon bars in Westerns where it was unwise to order sarsaparilla) had given way to the court of Jabba the Hutt, full of twitching, pulsating creatures in perpetual motion but lacking menace or much humour.

With only the middle trilogy of nine planned films completed, the vein seemed to have been worked out — or perhaps Lucas was wiser than

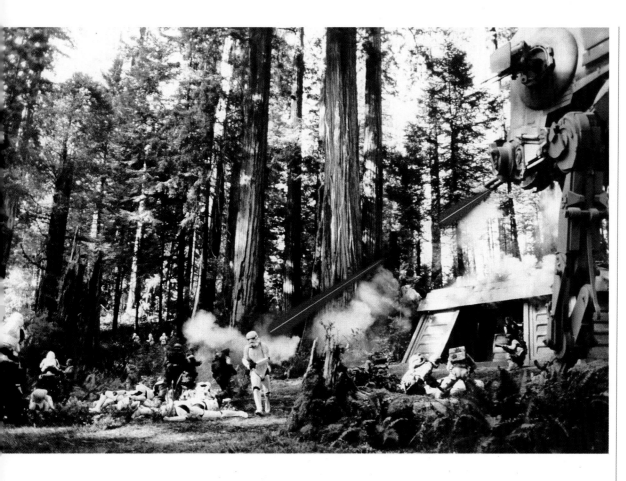

other compounders of sequels in stopping while he was still ahead.

A more direct comparison with *2001,* though later in time, is Peter Hyams's version (made in 1984) of Arthur C Clarke's 1982 novel, *2010.* Though the effects in the later film (Richard Edlund/EEG) are in some ways more sophisticated and computer-oriented, they won nominations rather than Oscars. And indeed they are subordinated to a more down-to-earth story which is now much more dated, because of its specificity, than that of the 16-year-earlier film. The Cold War theme, against which the collaboration of the Russian and American scientists is positively asserted as looking forward to the new world promised by the black obelisks and the climactic creation of a second sun, contrasts with the political neutrality, even blandness, of Kubrick's film. Kubrick can posit only a mystical promise of future (individual) development because he fundamentally has little faith in human nature or society, unlike Clarke (most sci-fi writers seem to have a deep-down streak of optimism, even when as downbeat as Philip K Dick or as ironic as Kurt Vonnegut). It's questionable in *2001* whether David Bowman's (Keir Dullea) classical rooms are finally a mansion or a prison, heaven or hell. His

ABOVE LEFT The final battle on the planet Endor in *Return of the Jedi* (1983). Han Solo (Harrison Ford) and Princess Leia (Carrie Fisher) are supported by Ewoks in their fight against the imperial forces for control of the reflector shield that protects the Death Star. Both the Ewoks and their opponents are, in effects terms, low-tech, that is people in suits — small people in the Ewoks' case.

reappearance in *2010* decisively resolves this, at the cost of making him come on like a Californian religious freak about 'something wonderful'.

Whereas *2001* stressed bareness, emptiness — not only in space but within the spacecraft too — the Soviet spaceship *Leonov* is lit up like a fairground, coloured lights everywhere; and when it enters Jupiter's atmosphere in a dangerous manoeuvre, it burns like the best firework ever — and survives. (An effect done with economical means, an epoxy-covered foam model of the braking balloons and an aluminium model of the *Leonov*, doused with liquid explosives.)

The efforts to simulate weightlessness in *2001* are largely omitted in *2010* except where obviously unavoidable such as inside HAL's 'brain' and, especially, in space itself, between the *Leonov* and the long-abandoned *Discovery*, Bowman's ship. Then, instead of being played for visual comedy, as when the stewardess in *2001* walks through a half-circle to exit upside down, still carrying her tray unspilt (done by imperceptibly turning the camera 180° in the opposite direction as she walks in a treadmill), it's a drama with wry comedy overtones as the nervous Curnow is supported by his braver Soviet oppo, Brailovsky (Elya Baskin) — a sequence largely performed by the actors themselves on wires. In this space-walk scene, Hyams insisted that the actors be lit only by key light (the light source in the story) with minimal fill (back light) from the blue screen. This meant devising an ingenious variant

BELOW A technician tries out a space toy for *2010* (1984).

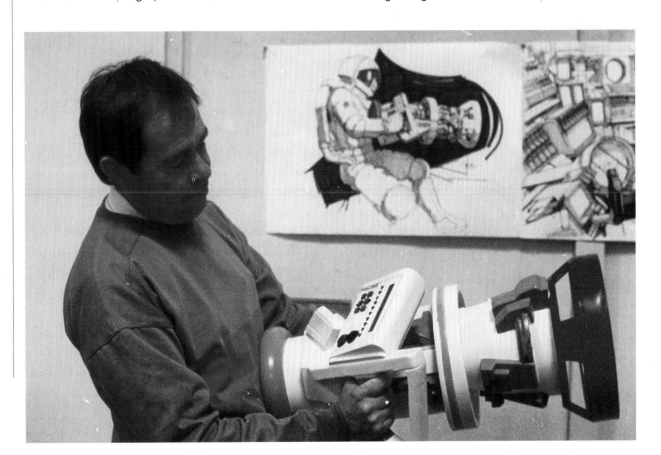

73

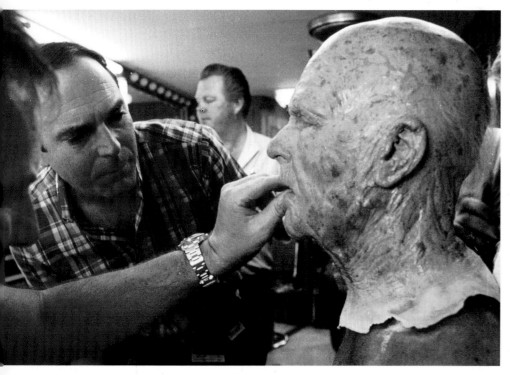

form of blue screen for the mattes, whereby the blue light was front-projected off a Scotchlite front-projection screen onto the back ('blue') screen. Though the round command module was built as a set, turned sideways, miniatures were used otherwise (and tiny models of the actors, photographed on an animation stand, for some long shots). Again, this sums up much of the difference between the two films — the wit of the weightless tricks in *2001* depends largely on their being done 'live' on very big sets.

The budgets for the two movies ($11 million versus $28 million) were roughly comparable, allowing for inflation; but unlike *Star Wars* ($9.5 million, less than half the cost of *2001,* allowing for inflation), *Alien* and others, shot mainly in England for economy, *2010* stuck to MGM's home base in Culver City and did not economize on actors, except by avoiding superstars. Despite a surprisingly long cast list the number of speaking parts in *2001* can hardly exceed a dozen, which, given the rigorously controlled banality of the dialogue, is probably fortunate. Kubrick presumably thinks that scientists, engineers and astronauts are dull dogs, a perception (or rather, opinion, since it's often untrue) that he may not have imparted to Clarke. A similar banality in *2010* is unrelieved by Kubrick's wicked irony, but is partly concealed by the excellent acting of Scheider, Mirren, Balaban, Lithgow, Baskin, and, of course, Douglas Rain again as the voice of HAL — he alone had escaped from Kubrick's anti-acting regime in *2001,* to become the only character that anyone cares about or indeed remembers.

MGM's studio at Borehamwood, on the northwest edge of London and just along the road from Elstree, was made by Kubrick to accommodate a space station interior over 300 feet (90m) long, sloping up at one end nearly 40 feet (12m). The background screen for the African transparencies in 'The Dawn of Man' was 40 × 90 feet (12 × 27m). The centrifuge in which Poole (Gary Lockwood) jogs was some 33 feet (10m) high. Even the space station model by Wally Veevers was over 8 feet (2.5m) across, while the *Discovery* was 54ft (16.5m) long on

ABOVE & OPPOSITE
Keir Dullea undergoes ageing make-up for *2010* (1984), including an overall rubber latex 'skin'. Luckily for him, he made only fleeting appearances as an old man, reprising his last scenes in *2001*. Otherwise he was able to resume his youthful self, having progressed to a spiritual state beyond flesh. Michael G Westmore, of the great Westmore family of make-up artists, was nominated for his work on *2010,* but Dick Smith and Paul LeBlanc took the make-up Oscar for *Amadeus* (1984).

74

a 150–foot (45–m) track, unthinkable by modern standards and nowadays unnecessary too. All the *Star Wars* hardware, so convincing on-screen, would look like toys by comparison. The figures for *2001* can be compared with those for *2010* (see *American Cinematographer*, July 1968 and *Cinefex* No 20, Jan 1985). The *Leonov* was 12.5 feet (3.8m) long and approximately 8 feet (2.4m) high, with an additional 6 foot (1.8m) version to scale with the *Discovery* at 12.5 feet (3.8m). (All the original models, including HAL's red eye and innards, had been destroyed, apparently because MGM were unwilling to pay storage charges in Britain!)

Kubrick, who was personally in charge of special photographic effects as well as of the film overall (similarly Hyams was, unusually, director of photography on his own movie), deliberately chose old-fashioned in-camera techniques where they would work. For example, on a second camera pass a projector was run along with the *Discovery* model to project action within the craft, seen at the windows, the windows having been blacked out the first time.

The slit-scan mechanism was used in the 'Stargate Corridor' sequence to suggest superfast and dizzying motion in some new dimension beyond normal space/time. It was developed mainly by

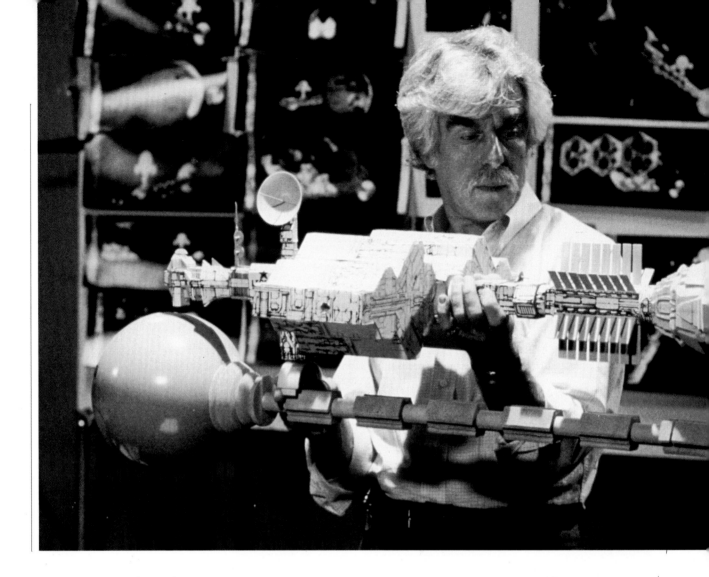

Trumbull, with Kubrick's encouragement, to reproduce on a far bigger scale some of the experiments done by John Whitney Sr to make abstract, flat animation — approximately the film equivalent of abstract expressionism in painting (Pollock, Rothko). A narrow slit, moving across the film plane (or up and down or, later, spinning around), exposed it a little at a time; meanwhile, artwork was moved on some other pattern or jiggled about almost kaleidoscopically to give an effect of distortion.

This is quite easy to do on an animation stand, with the camera pointing down on to a flat board which supports the artwork. But Pederson, who drew Trumbull's attention to Whitney's work, and then Trumbull himself, wanted a three-dimensional effect. So Trumbull started moving the camera in and out, and stopped the lens down to a tiny aperture for maximum depth of field (he had already been experimenting with zoom lenses for the cockpit readouts in other sequences). He produced Polaroids that Kubrick approved off, and got the go-ahead to set up a kind of gigantic horizontal animation stand.

ABOVE The small models, scaled to each other, of the *Leonov* (in technician's hands) and the *Discovery* for *2010* (1984). These may be prototypes, since they are about half the size of the scaled models referred to in *Cinefex* magazine (No 20, January 1985). They were designed for this production by Syd Mead, though the *Discovery* was quite closely based on the original version in *2001: A Space Odyssey* (1968).

This involved a 65mm camera that could do stop-motion by leaving the shutter open for an extended time and also refocus automatically while moving back and forth on a track as well as up and down, if necessary. The slit mechanism between the camera and the artwork, instead of being a few inches long, had to be about six feet (1.8m) long. Instead of a flat board, the artwork was mounted on 'easels', giant panes of glass, 5½ × 12 feet (1.7 × 3.7m), which moved to and fro on tracks, as well as sideways or up and down.

Though this sounds cumbersome by comparison with modern computer graphics (which is what these effects appear to resemble today), it was also quite flexible. It was certainly slow, but then computers somehow nowadays can take months to turn out a few seconds of screen time. In the late 1960s it was considered impossible to generate computer imagery at a high enough resolution to project onto a Cinerama screen — the electronic equivalent of 'grain' would have been unacceptably coarse and spotty. There are miles of computer imagery in *2010* to fill the video screens on the *Leonov*, then taken for granted, though it involved much work and Sony technology.

Obviously *2010* was operating under constraints — of increased scientific knowledge of the planets and of space travel — that did not exist in 1964-68. To take only one example, the planet Jupiter had to be represented correctly, including its moving cloud formations, before the fantasy element where a black hole containing obelisks 'devours' the planet and turns it into a sun. This work was subcontracted by EEG to John Whitney Jr and his Digital Productions — John Whitney Sr was a pioneer of computer animation whose abstract films inspired Con Pederson and Douglas Trumbull to try slit-scan. According to *On Location* (January 1985), a trade paper, they achieved 130 seconds of film at a resolution of 3000 × 1620 pixels (that is, nearly five million 'bits' of picture information) in mapping flat still-picture data on to a simulated sphere and programmed in movements from a map of wind-currents on Jupiter. And added to this scientific accuracy, of course, is a wholly imaginary event. Meeting this challenge, Whitney and Gary Demos won an Academy plaque in the Technical category.

BELOW Helen Mirren as the Soviet captain of the Leonov, a floating fairground of coloured lights, in *2010* (1984).

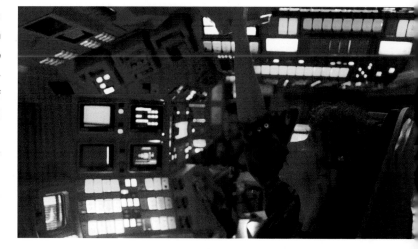

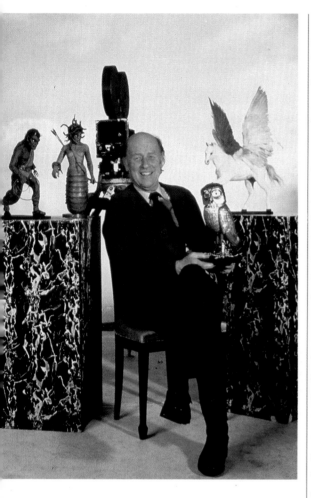

To conclude with figures: *2001* took $25.5 million in NA rentals (130
per cent over its estimated negative cost) and was a worldwide hit; *2010*
took $20.1 million, just under three-quarters of its negative cost.
Allowing for TV and video income, it's probably into profit by now.

ANIMATED MODELS
MECHANICAL

Animated models of robots, as opposed to those of organic creatures,
do not need to move 'naturally' but they still need to move convincingly
— and they must look convincing too. They are often made in a number
of different sizes, like the models already discussed, for the purposes of
different kinds of shot. Their movements are often, but not necessarily,
created by stop-motion.

The mechanical owl, Bubo, is probably the most sympathetic creation
in *Clash of the Titans* — in fact, he's more likeable than any of the gods
or humans. Since Athena (Susan Fleetwood) is reluctant to part with her
symbolic owl, her trademark of wisdom, Hephaestus (Pat Roach)
constructs an exact mechanical replica. Perhaps the scripwriter,
Beverley Cross, had in mind the Grecian golden nightingales of which W
B Yeats writes in his poem 'Sailing to Byzantium'. Anyway, the first form
of Bubo in the film was indeed a real owl. Two sizes of metal models
were constructed by Ray Harryhausen's team: the lifesize ones for use
with the actors, employing radio-controlled movements (three were
made, with various capacities for action); and the distinctly smaller
animation model for stop-motion. Harryhausen has habitually used
quite small models, often in two or more scales, for his stop-motion,
hands-on animation method, which he called Dynamation or, latterly,
Dynarama. It can come as a shock if one sees the tiny scale of monsters
or creatures that appear quite huge on-screen.

Whereas the radio-controlled motors could only control the owl's
head, wings and eyes in simple, repetitive motions, Dynarama enabled
it to fly and even to act, or at least intervene in the action, notably the
frequent fights. The slightly jerky movements almost inseparable from
hands-on animation are perfectly acceptable and even comic in a
mechanical creature that is not intended to deceive the audience.

In *RoboCop,* the monstrous law enforcement droid ED 209 was first
built full scale (7 feet/2.1m tall) of plastic on a wooden frame, with
movable joints for setting positions and altering them between takes,
but no intention of on-screen motion or facility for creating it. Then two

1–foot (30–cm) tall stop-motion models were made of thin plastic on a metal framework, since the timetable demanded two simultaneous animation set-ups, using rear projection for economy. The droid was conceived as, in part, a satire on US technology, particularly automotive design, intended to look impressive and desirable to buy rather than to function well, with its 'killer whale' head, no eyes but a large, useless hole for a mouth.

ED 209 was, however, menacingly equipped with a 20–m gun and three rockets on its right arm and two further guns on the left. Urged on by Verhoeven, Phil Tippett and his team pushed rear projection to its limits and almost beyond, having the puppet move towards the camera and even once step right over it, a process that involved partially dismantling the leg. Lacking the elaborate Go-motion system of rods and computer control that Tippett had devised at ILM for the dragon in *Dragonslayer* (1981), intended to create a slight blur as each single-frame shot was made (since in real motion the subject moves fractionally in the one-fiftieth of a second for which one frame is exposed), they simply shook the puppet a bit each time. The result is not quite organic movement nor is the pace quite lifelike; but since ED 209 is a machine, and increasingly a comic one at that, this is hardly a problem. In fact, it accentuates the lavishly comic-book style and ironic wit of the whole film. During the first big fight with RoboCop — which involved a stuntman, of course, and at one point a tiny puppet of RoboCop — the action is so fast and furious that details hardly register. During the final confrontation, the comedy reaches its height as it emerges that, owing to a design oversight, ED 209 cannot negotiate stairs. After frantic scrabbling, it falls ignominiously. For this, a miniature stair set was built and the actual fall filmed first, using the

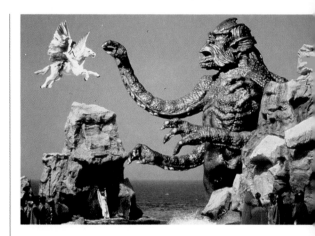

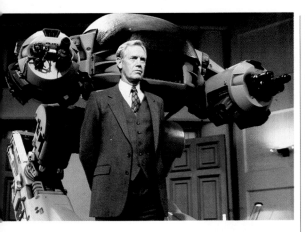

outside plastic skin of one puppet with the armature removed and replaced by shot for added weight. The scene of scrabbling around at the top of the stairwell and the subsequent scene of ED 209's lashing about furiously at the foot of the stairs, unable to regain its footing, were then animated, the latter mostly using back projection and maximum blurs — almost literally hands-on, with the animator waggling the legs with wires during the one- or two-frame takes.

The later scenes of *The Terminator* (1984) involve a metamorphosis of the title role, previously played by Arnold Schwarzenegger, into a huge metallic endoskeleton. The Terminator has been sent back in time from a future world dominated by machines to assassinate Sarah (Linda Hamilton from TV's *Beauty and the Beast*). Sarah's death is vital to the machines as she is to become the mother of John Connor, the charismatic leader of the remaining pockets of human resistance in the Terminator's own time. Reese (Michael Biehn), a human guerrilla, is simultaneously sent back in time by Connor to protect Sarah and, unwittingly, to ensure Connor's own conception. The parts for the full-sized robot were cast in epoxy and aluminium powder with steel ribbing

ABOVE In *RoboCop* (1987), Dick Jones presents his Enforcement Droid, ED 209. This production shot shows the full-scale but non-working model.

BELOW In *The Terminator* (1984), Arnold Schwarzenegger tracks Sarah Connor to the Tech Noir nightspot and thoroughly devastates it.

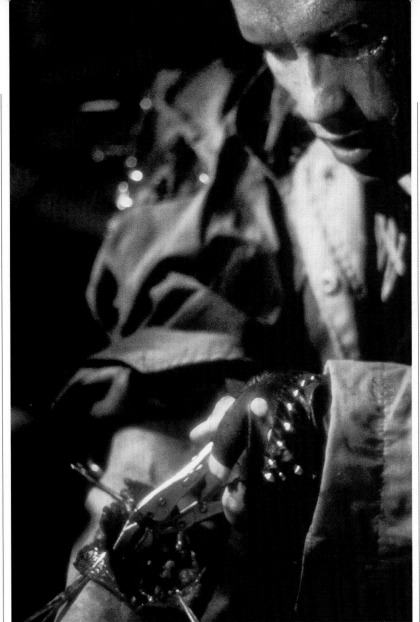

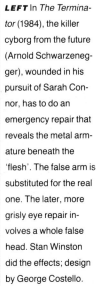

for strength; the pieces were then chromium plated. Though the 6-foot 2-inch (1.88–m) figure weighed 100 lb (45 kg), making it quite difficult to manipulate as a puppet, its solidity and heaviness were convincing on-screen as another incarnation (or decarnation) of the Schwarzenegger character. For walking scenes involving the full-size model, only the upper half appeared, making things easier for the puppeteer underneath, since the weight was reduced by about a third. While arms and, for close-ups, legs and feet were operated manually by puppeteers, the head was radio-controlled, except in big close-ups requiring rapid movement; then the radio control would be removed, leaving room for the puppeteer's hand.

Walking scenes at full length required stop-motion, and for this an exact replica, 2 feet (29cm) tall, was constructed — twice the normal

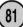

size of small-scale models because of the detail required in order to cut together the full-size and small-scale model shots. The framework was aluminium, with brass fingers and steel feet, and the parts to cover it were cast in epoxy mixed with aluminium powder, like the full-size version, and similarly chromium plated. To add realism to the stop-motion scenes, small camera movements were introduced, including a couple of slight pans, rather than keeping the camera rigidly still for a whole series of single-frame exposures. During the exposures, blurs were added by the simple but effective expedient of interposing vaseline-smeared glass between camera and model, varying the smears from frame to frame. Since many of the skeletal Terminator's moves were rapid, they had to look convincing as live action, though not necessarily organic.

Although Reese manages to bomb the Terminator before himself dying after their final encounter in a factory — a rigid figreblass replica was used for the explosion shot — the skeletal robot, minus both legs and one arm, still manages to pursue and finally catch Sarah. But she has lured him into a giant press, through which she has crawled, and is just able to throw the switch. To make the crushing of the torso believable, it had to collapse like metal, not break like fibreglass. So a special version made of polyurethane was positioned and crushed in the press. The Terminator is terminated — by a fellow machine, properly subordinated to human control — while Sarah, already pregnant by Reese with John Connor, survives. (One film surely crying out to be made is about a special-effects team which finds that their creatures are coming to independent life and taking over the movie — or the studio, or the world.)

In conclusion, brief reference must be made to Douglas Trumbull's directorial debut, *Silent Running* (1971), an ecological *flop d'éstime* that can no longer be considered underrated, though not quite a cult film. Its only real fault was that it was ahead of its time. A huge spaceship supports forests that can no longer survive on earth. Ordered to destroy them, scientist Lowell (Bruce Dern) chooses to destroy his philistine colleagues instead and save one forest. He has to rely on three small robots, or drones, Huey, Dewey and Louie, whom he programs to help him. These are played by four quadruple amputee performers, one a woman, so that they look like genuine robots, not 'men in suits', yet are believable as characters. Less than half Lowell's height, they become his surrogate children. Though one is lost and another damaged, the survivor is sent off into space with the forest when the scientist destroys himself with his ship to conceal the fact that the forest still exists.

ABOVE Directing his first film, *Silent Running* (1972), Douglas Trumball managed to stretch a tiny budget to make a convincing model of an elaborate assembly of space-craft.

ORGANIC

Undoubtedly the most popular, indeed cuddly, alien of recent years has been ET — perhaps *Gremlins* (1984) was even conceived partly as an 'answer' to *ET. Gremlins,* co-produced by Spielberg but directed by Joe Dante, is populated by creatures that are initially cuddly and ultra-cutesy (not unlike those in the 1967 *Star Trek* episode, 'The Trouble With Tribbles'). The first gremlin remains so, but spawns ultra-naughty variants, prone to drinking, tinkering dangerously with machines and occasionally killing, though their essential childishness emerges in their noisy but enthusiastic appreciation of *Snow White and the Seven Dwarfs* at the local cinema. The lesson is that cute creatures can turn nasty — as is sometimes true even of domestic pets — and that cosy sentimentality masks essential truths.

ET, of course, never turns nasty, at most he's marginally naughty. Primarily ET, as realized on-screen, was the creation of Carlo Rambaldi, an Italian sculptor and inventor (his own self-description), who had formerly worked with Spielberg on *Close Encounters of the Third Kind* (1977) and with Ridley Scott on *Alien* (1979). As described in *Cinefantastique* 12/2-3 (1982), Rambaldi and his team designed and made the models. The full-size versions were 3 feet (90cm) tall, plus another 4 inches (10cm) if the neck was extended. Once the rubber outer skin was completed, the metal core controlling the mechanical and electronic movements was fitted with a flexible plastic cover on which to support the skin. Of the three main models, the fully electronic one was the most elaborate, with 85 separate movements controlled through a cable, 35 of them in the head. The lighter electro-mechanical version had 60 movements, 30 of them in the head, and was also cable-controlled. The third was inhabited by small people, half a dozen of

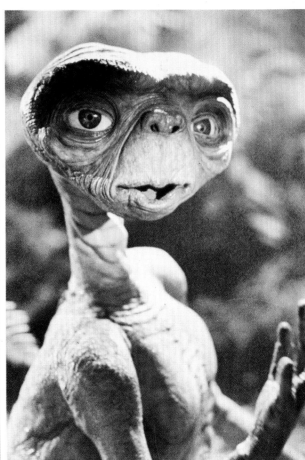

them at various times; of whom Pat Billon, 2-foot 10-inch (85-cm) tall, became the best known and most publicized. Though requiring no cable, the third model still had 10 radio-controlled movements for eyes, lids and hands. Rambaldi also created an extra head with 20 further movements of eyes and tongue. The total cost was $1.4 million, a substantial part of the $10.6 million budget. Having several models economized shooting time since a second unit could operate simultaneously. Using actors for walking, running, and (according to Billon) sitting in the cycle basket is estimated to have saved $1 million in the model budget. Rambaldi, however, reckoned that such scenes formed less than one-sixth of the total footage involving ET.

Rambaldi's work on the Alien's head in *Alien* could hardly be less cute, but otherwise there were several points in common, for example, the use of cable control, and of three basic models with different potentialities. He was following a basic design already chosen by Ridley Scott, the director, developed by the Swiss surrealist painter H R Giger from his own painting, 'Necronomon IV' in his 1976 book, *Necronomicon*. Giger was asked to produce designs not only for the full-grown monster, especially its head, but also for the two earlier stages,

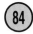 84

the 'face-hugger' (the piece that comes out of the egg to attach itself to an animal/human and force an embryo down their throat) and the 'chest-burster' (the small creature that has grown enough within the host to burst out to an independent existence, killing the host in the process). Eventually Giger contributed to making the backgrounds too. The three alien forms were originally to be realized by Roger Dicken; but he completed the small forms only, and Rambaldi was called in at short notice to do the Alien head. The intention was not to show the Alien at full length, if possible, and indeed he is scarcely seen more than fleetingly before the end, when he is ejected from the shuttle craft of the destroyed *Nostromo* by its last survivor, Ripley (Sigourney Weaver). The idea was to get away from the 'man in a suit' which had become a cliché of space fiction and alien fantasies. In fact, the point of having him played by a 6-foot 10inch (2.1-m) Nigerian student, Bolaji Badejo, plus a rather less tall stuntman, was largely lost.

Since Scott is primarily neither a storyteller nor a director of actors — though the film was strongly cast, making the latter point less significant — he sometimes resorted to tricks to get a response. The best-known instance is the scene where Kane (John Hurt) 'gives birth' to the small Alien 'chest-burster' through a false chest model (operated by Dicken under the table and an effects team around). The other members of the

RIGHT At Shepperton studio, H R Giger (top), the Swiss surrealist artist, supervises the creation of a plaster version of his design for the Alien in *Alien* (1979). The painting is not the one referred to in the text, 'Necronomon IV', but a close variant of it.

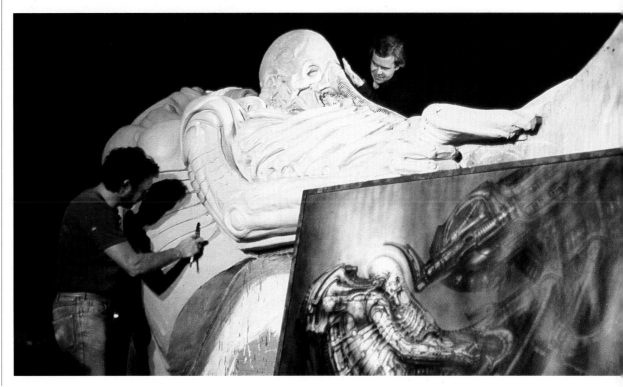

ABOVE The monster glimpsed in action in *Alien* (1979). The head was realized from H R Giger's designs by Carlo Rambaldi.

Nostromo's crew were splattered with animal guts, not having been warned beforehand, so that their reactions were real and spontaneous.

Alien is primarily a mood piece as well as a visual display — there are slow passages in which little happens, building up suspense for the main action scenes, the deaths of six crew members. Ash (Ian Holm) — a well-disguised robot — is in league with the ship's computer, 'Mother' (voice: Helen Horton), to preserve the Alien as a specimen at the sacrifice of the humans. The disparate nature of the crew, along several oppositions — male/female, white/black, British/American (North/South), human/robot — seems intentionally to limit their interactions; they're a bunch of loners. So indeed is the Alien — and he has no means of propagation.

Aliens (rightly not called *Alien 2*) is a different, even contradictory film. Though it was again made in England (Pinewood this time), surprisingly few credits recur from the shoot of seven years earlier. The

emphasis of the later film is far more on team action. The marines' sexist and racist mutual abuse is part of their camaraderie, with the women getting the best lines: 'Were you ever mistaken for a man?' asks one hapless male of Private Vasquez (Jenette Goldstein), setting himself up for 'No; were you?' The Ripley of *Alien* was a lonely career woman; her potential romance with Captain Dallas (Tom Skerritt) never got started. The new Ripley not only has her romance — with Corporal Hicks (Michael Biehn, from *The Terminator*) but becomes a surrogate mother, of 'Newt' (Carrie Henn), the colonized planet's last survivor. Though the Company is still evil and still tends to give its spacecraft

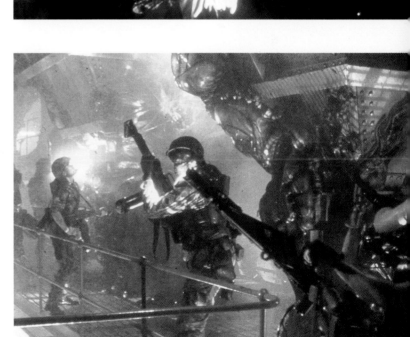

Conradian names ('Sulaco' this time, instead of 'Nostromo', suggesting that someone other than Ridley Scott had actually read *Nostromo*), the devious company man, Burke (Paul Reiser), is now the loner, and he behaves exactly like a Hollywood executive, or agent, intent on a deal. The almost obligatory robot, Bishop (Lance Henriksen), is this time a hero and overcomes Ripley's initial suspicions. Unlike Ash, he can still function effectively when ripped in half (after all, 57 years of technical progress have elapsed) and saves her life as well as Newt's. The evil 'Mother' is now transferred to the opposite side and is the Mother of all the Aliens, hinted at by the eggs in the first film. She is finally defeated by Ripley operating a mechanical lifter, a power loader — a more sophisticated reprise of Sarah working the hydraulic press to 'terminate' her adversary in *The Terminator* (Cameron's self-confessed love of machinery is apparent again).

The story rips along at a cracking pace instead of suspensefully

RIGHT In *Aliens* (1986), an emergency council of war in the wrecked shuttle craft involves Corporal Hicks (Michael Biehn), Private Vasquez (Jenette Goldstein) and Ripley (Sigourney Weaver), while young 'Newt' (Carrie Henn) looks on anxiously.

RIGHT It is a case of 'Marines, let's go!' in *Aliens* (1986), a film of big spectacular effects and rapid action — most of it leading to disaster, since all but one of the marines are killed, and even the survivor is seriously wounded. This scene was shot in a disused electricity generating station in Acton, London, expensively customized for the movie.

loitering, yet it somehow lacks the frisson of *Alien* in its businesslike efficiency. Interestingly, though the budget had risen to $18 million (from around $9-10 million for *Alien,* seven inflationary years earlier), rentals were up hardly more than 8 per cent, from $40.3 million to $43.7 million; the more conventional, apparently more 'popular' film actually drew fewer people to the cinema, at least in North America.

The Alien effects on the second outing were in the hands of Stan Winston, who (like Rambaldi) won an Oscar for his efforts. Rambaldi meanwhile was working on *King Kong Lives* (1986), which cost the same as *Alien* and took just $1.7 million in rentals, besides winning no Oscars. Winston's problem was to create many Aliens rather than one and to make them mobile, agile and fast — Badejo had been weighed down by his rubber suit. Size was not a great problem, according to *Cinefex* 27 (1986), but very lightweight foam pieces had to be attached to black leotards to substitute for the original heavy suit. Stunt persons

BELOW Ripley (Sigourney Weaver) encases herself in a mechanical lifter (actually lightweight plastic slung on wires) to fight the Alien Mother in *Aliens* (1986).

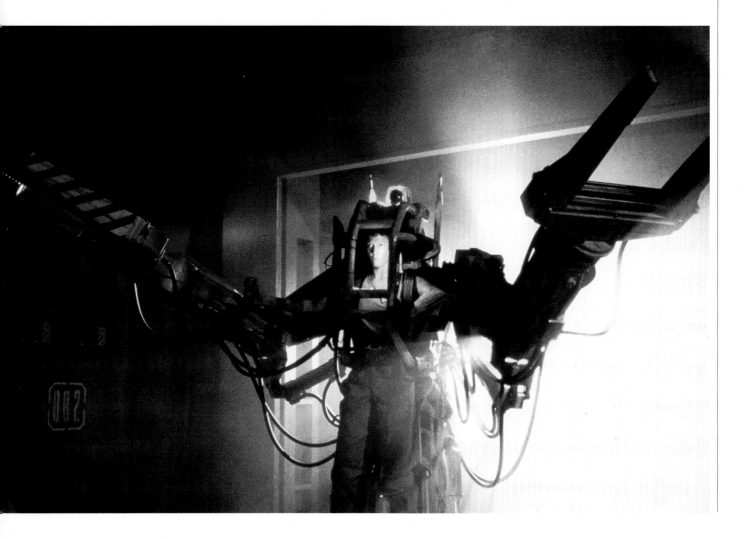

and dancers, not exceptionally tall but fairly thin, were employed to get unusual, quirky movements, and the scale was faked by using additional puppets, 8 feet (2.4m) tall and very thin, of several types for individual shots, some merely to be destroyed.

The Queen Alien was built in two versions, a full-size mechanical one also using two stuntmen inside, and a quarter-sized puppet, operated mechanically, since Cameron, who had accepted stop-motion for the Terminator's final stage, did not like it for an organic creature. (He also disliked travelling mattes for live action, as being too artificial, preferring front and rear projection. Indeed, his penchant for realism had led to his taking over a disused power station in Acton, West London, thoroughly refurbished, for the Aliens' nesting place.)

Since the Queen was more spiderlike than humanoid in form, 'she' could safely be shown in more detail and had to be for the climactic battle, Queen versus Ripley plus power loader. With both Queen and loader in shot, hanging on wires not seen, the number of control crew

ABOVE Snake-haired Medusa, who turns men to stone, is one of the Dynarama models in *Clash of the Titans* (1981). Perseus kills her by looking only at her reflection in his shield. Medusa was Ray Harryhausen's favourite model from this film.

during the five-day shoot of this sequence alone was obviously large but no accidents occurred. In particular, the power loader, made of light plastic for manoeuvrability on the wires, stood up well to the battering — luckily, in that no spare had been constructed. The Queen, trapped under the power loader in the air lock, is finally ejected into space, echoing the conclusion of *Alien*.

To return to *Clash of the Titans* on the problem of stop-motion for organic creatures, Harryhausen made what appears to be a considerable error of judgement, which has to be set against his success with Bubo the Owl. The monster Calibos, a half-divine man who has been deformed as a punishment by the gods but retains the power of speech and other human characteristics — including a curiously ineffectual lust for the pretty Andromeda (Judy Bowker) — is doubly cast as a Dynarama (or Dynamation, ie stop-motion) model and as an actor (Neil McCarthy), a decision not only unprecedented but unwise.

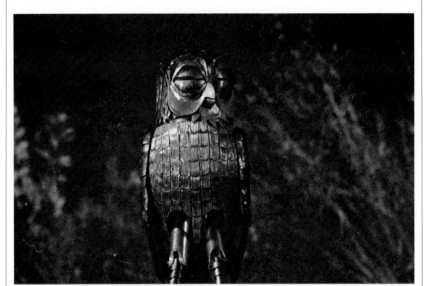

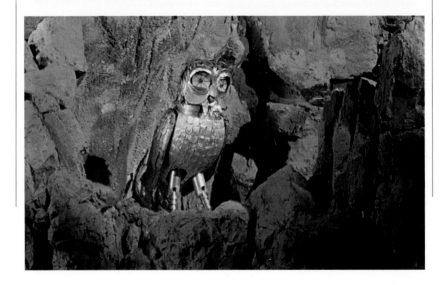

BELOW & BOTTOM
Bubo, the mechanical owl created by Hephaestus for Athena in *Clash of the Titans* (1981). Actually he was made by Colin Chilvers, with radio control by David Knowles.

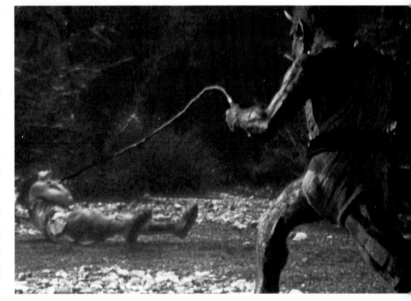

ABOVE & RIGHT
Calibos, Lord of the
Marsh and son of the
goddess Thetis (Mag-
gie Smith), has been
deformed by Zeus
(Laurence Olivier) for
slaughtering a sacred
herd of flying horses.
When Perseus kills
him, Thetis orders
Andromeda's sacrifice
to the Kraken. Calibos
was played partly by
Neil McCarthy (close-
up) and partly by a
model, a compromise
that does not work
well.

Whereas director Desmond Davis
gets only wooden — or rather,
plastic — performances from Judy
Bowker and Harry Hamlin (as
Perseus), McCarthy conveys rather
well the bitterness of a handsome
young man deformed irreversibly.
The model, used in fight scenes,
for instance, inevitably draws
attention to its nonrealistic move-
ments by contrast with the real
actor, whereas stylized characters
like snake-haired Medusa or Dios-
kilos, the two-headed dog, at least
have no real-life equivalents.

MAKE-UP

The area where people, often actors doubled by stuntpersons, play
monsters or semi-monsters (for example, werewolves) or indeed
androids is loosely classified under 'Make-up', though it sometimes
seems remote from the theatrical traditions of slap and wigs.

The category extends from Rambaldi and Winston to the last major
survivor of the great Westmore clan, Michael G Westmore, whose
credits range from *Rocky* (1976) to *Roxanne* (1987) by way of *2010* and

Mask (1985, Oscar winner). The man who provided Daryl Hannah with a mermaid's tail in *Splash* (1984), Robert Short, went on to win his Oscar for *Beetlejuice* (1986). Chris Walas, who created the gremlins in *Gremlins,* got his Oscar for turning Jeff Goldblum into the Fly in *The Fly* (1986) and went on to direct *The Fly II* (1989).

Dick Smith has cornered the market in ageing, making his name with *Little Big Man* (1970), in which Jack Crabb (Dustin Hoffman) claims to have reached the age of 121. Smith devised a technique using eight pieces of latex rather than one overall mask, including convincing eyelids. Marlon Brando, in *The Godfather* (1972), amiably declined to have the patience for such five-hour make-ups: an hour and a quarter was his maximum, but then he was only ageing 20 or 25 years, not 90. The only special feature for him was the jowl fixture inside his mouth, a wire frame with two plastic pieces attached. Apart from a bit of liquid latex and normal ageing make-up, the rest was mostly acting — Brando has been the cinema's greatest deep-down Method mimic, as well as a great actor. But perhaps Smith's most spectacular achievement was the ageing and withering away of John (David Bowie) and — using puppets — Miriam (Catherine Deneuve) in *The Hunger* (1983), directed by Tony Scott, Ridley's brother. They play vampires hundreds of years old, so their destruction needed a series of rapid stages. Smith worked with Carl Fullerton on the mummy effects. Whereas Deneuve was able to delegate her ageing to a stuntwoman and dummies (thus preserving her 'look', as she calls it in her very precise and fluent English), Bowie had to act several scenes as he aged catastrophically through lack of fresh blood and then, despite one last desperate murder, perishes.

RIGHT Satipo (Alfred Molina) is fatally impaled on a spike in *Raiders of the Lost Ark* (1981). Make-up artist Chris Walas applies his expert touch not to Molina himself but to a life-size plaster cast.

This experience of combining special make-up with puppets or models, unusual in Smith's career, nonetheless illustrates the peculiar calling of a special-effects make-up artist, and the variety of skills he (occasionally she) needs or has to call on to do the job. Rick Baker must get a brief mention for his Oscar-winning work on that darkest of tragi-comedies, *An American Werewolf in London* (1981), also John Landis's masteriece to date. The transformation of David (David Naughton) from nice New York Jewish boy to very scary werewolf is an outstanding achievement, with elaborate props and each stage exactly plotted and, despite a team of 30 stuntpersons, Naughton must have acted quite a lot of this himself. The gradual putrefaction of his friend Jack (Griffin Dunne) is also precisely charted at each grisly reappearance, as he blithely brings the message that suicide is the only solution to the puzzled David.

ABOVE In a production shot for *The Fly* (1986), director David Cronenberg (left) inspects the 'damage' on Jeff Goldblum, who plays a scientist whose obsession with teleportation (*Star Trek*-style computer transportation of live creatures) leads to his mutation into a half-human, half-fly monster. Make-up by Chris Walas.

93

Baker's later, less delirious work includes *Gorillas in the Mist* (1988) almost a case of (to quote D W Griffith on Henry King's *Tol'able David*, 1921) 'Too good, dear boy, too good, too good!' As Philip Strick and others have commented, his fake gorillas are so indistinguishable from the real ones that they all start to look slightly suspect — particularly since five 'mime artists' but no stuntpersons are credited, and neither

BELOW LEFT Andrew Robinson, best rememberd as the villain in *Dirty Harry* (1971), undergoes the unpleasant experience of being cast in plaster for Clive Barker's British horror film, *Hellraiser* (1987). Robinson plays Larry, who has the even worse experience of being skinned alive by his dead but semi-resurrected brother, Frank. Frank needs Larry's skin to complete his resurgence — but ends up killed by demons again. While the plaster cast stands in for the flayed Larry, Robinson takes over Frank's role.

ABOVE Dick Smith's contribution to *Amadeus* (1984) was confined to the ageing of Antonio Salieri (F Murray Abraham), Mozart's arch-enemy and rival composer — he left the rest of the cast to Paul LeBlanc and several Czech assistants. Smith lent Salieri his own forehead wrinkles (by way of a wax cast), enhanced them and walked off with an Oscar. Abraham got one too (Best Actor).

director Michael Apted nor associate producer Baker could have risked Sigourney Weaver's getting seriously injured.

However, only two films and two make-up artists can be examined here in a little more detail: *RoboCop* (Rob Bottin) and George A Romero's *Day of the Dead* (1985, Tom Savini). The latter film was the third, most underrated and least commercially successful of the trilogy that began with the low-budget cult film *Night of the Living Dead* (1968) and continued with *Dawn of the Dead* (aka *Zombies*, 1979).

Incidentally, the choice of these two films represents a critical opinion, not only of their special effects — though these are outstanding too, even if Oscar turned a blind eye — but of the films as a whole. While the proposition that *RoboCop* is a more interesting film than, say, *Star*

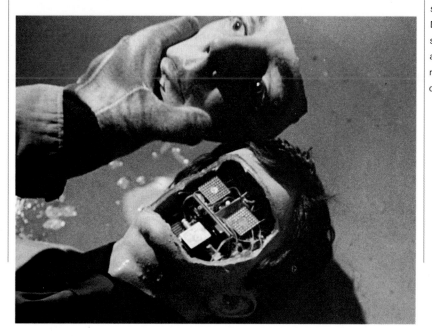

LEFT & BELOW
Futureworld (1976) is a sequel to *Westworld* (1973), the movie that featured Yul Brynner as a robot gunslinger. A reporter (Peter Fonda) suspects that something is wrong at Delos, the robot-staffed fantasy park, and discovers that the robots have taken over.

Wars might meet with little opposition among the over-12s, preferring *Day of the Dead* to *RoboCop* might appear downright eccentric or absurdly cultish to some readers. To others, though, including horror-film experts as diverse as Robin Wood and Kim Newman, this would seem the right choice. Both movies relate to the tradition of comic-strip horror. But while *RoboCop* is basically an entertaining comedy with some 'serious' ideas thrown in for ballast, *Day of the Dead,* despite grotesque comedy elements, mostly involving blood-and-guts, is fundamentally more serious, an adult rather than an 'adult' movie.

ROBOCOP

The most striking make-up effects in *RoboCop* are the death of Officer Murphy (Peter Weller), his reincarnation in a cyborg version as

RoboCop, and the 'Melting Man', into which the especially unsympathetic gangster Emil (Paul McCrane) changes very shortly before his death. (Factual information is taken from *Cinefex* No 32.) All these are very much in the comic-book idiom that dominates the film throughout — including the dialogue — but they require a degree of realism and detail unnecessary in the freer graphic comic medium.

When Murphy is shot to pieces by the sadistic Clarence Botticker (Kurtwood Smith) and his gang, he loses a hand and then an arm before finally being shot in the head. For this scene, Rob Bottin used the following: a false floor; a three-section fibreglass model of his hand, able to be blown apart by compressed air, for safety; a polyfoam right arm attached with velcro; a full torso and head puppet, minus the right arm, but with an explosive charge, since it replaced Weller in shot, and with a mechanism for making it sit up. Much of this elaborate set-up hardly survived in the final cut, mainly for censorship reasons.

LEFT In *Greystoke — The Legend of Tarzan Lord of the Apes* (1984), Lord John Clayton (played here by Daniel Potts) is abandoned in Africa when his parents die and brought up by a female ape, Kala (Ailsa Berk), who has lost her own cub. Because the young actor is closely involved with the apes in a drama of family and leadership rivalry, the principal apes are played throughout by actors, as in *Planet of the Apes* (1968), and there is less emphasis on using real animals than in *Gorillas in the Mist* (1988). Primate costumes by Rick Baker, who also did *Gorillas*.

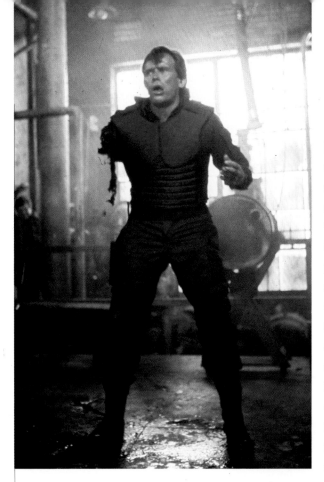

The RoboCop is basically a 'man in a suit'; but in the story he has been so reconstituted that even his skin, seen only at his face and not much there until he takes off his helmet, is supposed to be toughened like plastic. The suit had to be practical, which in practice meant seven different suits for different functions (some worn mainly by stuntmen) and two more for his damaged appearance at the end. The 40-lb (18-kg) suit consisted of two layers, a fitted black latex inner one and an outer armour of some 15 pieces in hard polyurethane with aluminium joins, plus a fibreglass helmet. The two drawbacks were that it initially took a long time to get into, and it was hot — the first problem was solved, the second not.

Perhaps Bottin's most memorable achievement, though, was the 'Melting Man'. Emil is the most unpleasant of a scarcely likeable crew (their penchant for quoting Shakespeare notwithstanding); he has even previously been 'killed' in the gas station explosion. However, as in an animated cartoon, he comes back undamaged. (Botticker had similarly gone through multiple plate glass windows — real glass, in fact, primed with explosive charges, not plastic ones — with no more than a cut or two and a designer-plaster.) Attempting to run down RoboCop in a disused factory, Emil is immersed in toxic waste and emerges with his flesh dripping off. This involved two main stages: the first was an appliance that covered most of the actor's head and chest, plus latex gloves for peeling hands. The second was added to the first, over the cheek and lower jaw, to give a further stage of disintegration. Emil gets little sympathy from the rest of the gang and then Clarence hits him with his car. Here a jointed dummy was fitted with both make-ups and the head was loosened — on impact, it rolled by chance up the windscreen. The in-car shot showed catering leftovers splattering across the windscreen. Since preview audiences rated it both best and worst thing in the film — presumably depending on level of squeamishness — it obviously made an impression.

98

RIGHT In *RoboCop* (1987), the previously lucky gangster Emil (Paul McCrane) gets his comeuppance from a vat of toxic waste and his body starts to melt away (effects: Rob Bottin). This is the second instalment of the make-up — the main foam latex appliance covering his head and chest is supplemented by a facial piece showing his jaw starting to drop off.

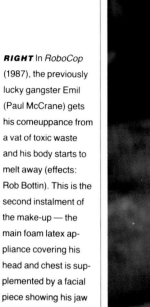

DAY OF THE DEAD

Romero is a provincial film-maker by choice and has been since the 1960s, long before this was common — if indeed it is even now, despite the growth of independent film-making and its important contribution to the artistically enfeebled Hollywood mainstream. New York-born, he has based himself in Pittsburgh, Pennsylvania, an unfashionable choice by any standards, inspired by the years he spent there studying art and then drama. (Biographical and technical information is from an enthusiastic book by a *Cinefantastique* writer, Paul R Gagne, *The Zombies That Ate Pittsburgh,* 1987.)

Monkey Shines (Orion, 1988) was to be Romero's first Hollywood venture, though still shot in the Pittsburgh area. Unfortunately it was not a commercial success ($2.1 million NA rentals), rather worse in fact, if taking inflation into account, than *Day*'s $2 million in 1985. Since *Dawn* had taken $7.38 million in 1979 and done well worldwide, United Film Distributors (UFD) was willing to put up a fairly large budget for *Day of the Dead* by Romero's standards.

Romero had in mind a much more ambitious script in which the zombies have more or less taken over, except in an island enclave where soldiers have trained them into an army and scientists are devising ways of using them as slaves. Most of the other surviving

(99)

humans, living in a squalid, crime-infested concentration camp, are used by the soldiers as meat for the zombies. Captain Rhodes (Joseph Pilato) and crazy scientists appear in this version, but it was too huge and ambitious, even with cuts, so it was replaced by the final script as actually used in the film. Though it was shot on a strict schedule, not in the looser manner of its two precedessors, some scenes and lines were improvised or contributed by the actors; for instance, Rhodes's last words to the zombies as they eat his guts, 'Choke on 'em!'

The effects in the film, apart from the odd live alligator, are to do with the dead and with dying. Inevitably they are gory, more so again than those Savini, who had been a photographer in Vietnam before his movie career, had developed for *Dawn*. The zombies consist mostly of two groups: one inside the underground complex, kept penned up in tunnels for 'research' purposes, the other outside the camp's wire perimeter. A third small group is encountered near the beginning, in a Florida town (along with the alligator), moving about in a desultory but slightly menacing way. The extras here were harder to recruit and less co-operative than the enthusiasts back in Pennsylvania.

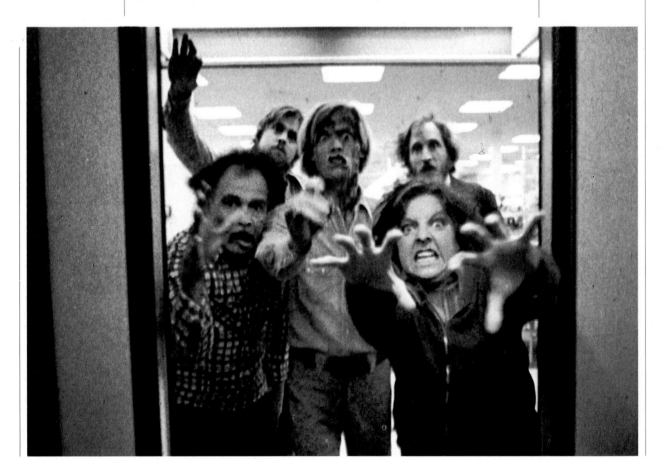

BELOW *Dawn of the Dead* (GB: *Zombies*, 1979) is the second in George A Romero's zombie trilogy, and the first of them in which Tom Savini took control of the make-up and effects.

100

The make-ups for these are mostly straightforward, apart from a few facial appliances to simulate injuries or decay. The crucial social question raised by the zombies, relevant to all societies, capitalist or communist, is 'Why should the many work for the few?' This issue is less prominent than in the original planned script, since they are not yet trained, just a mutinous underclass out for some kind of revenge. But their instinctive reactions, violence and cannibalism and the location of these instincts in the brain (which has to be destroyed to finally 'kill' them) is still clear. Id-like but asexual, they are the mirror-image of the soldiers (violent and threatening) and the insanely behaviourist scientist, Dr Logan (Richard Liberty), seeking domination and control, however meaningless, since they are outnumbered 400,000 to one. Sarah (Lori Cardille) is also a scientist, but she looks for understanding — without success. Still, she escapes from the 'mad scientist' category just as she partly escapes from limiting classification as (the only) woman. Her affair with Miguel (Antone DiLeo), the only hispanic among the soldiers and the only one succumbing to battle fatigue, seems to have petered out into pity on her side, recriminations on his — it is never really established as a physical or emotional reality. Her friendship with the Jamaican helicopter pilot, John (Terry Alexander), and the alcoholic Irishman, McDermott (Jarlath Conroy), is idyllic and asexual. Their

ABOVE In *Day of the Dead* (1985), Bub (Howard Sherman) is the only zombie who, having some faint memory of (army) life, proves to be partly trainable, although this only finally amounts to 'shoot and salute'. However, he remains more sympathetic, on the whole, than the psychotic and fascistic live soldiers; and is wonderfully played by Sherman, a classical stage actor.

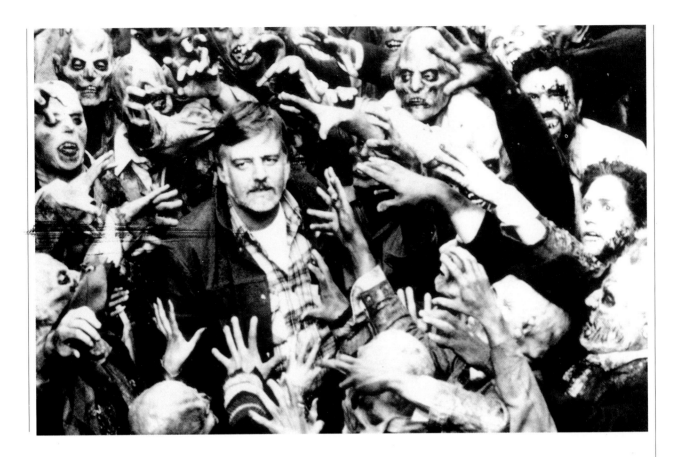

escape at the end to an island paradise may be a last dream or fantasy, or a gesture towards hope on Romero's part.

The most elaborate effects relate to 'Dr Frankenstein' and the lab where he dissects to little purpose. The faceless head and the zombie that spills its guts are created by means similar to those used for the death of Murphy in RoboCop. Trick tables conceal parts of the actors' bodies, and models are made for the missing parts, liberally spattered with gore and guts. The same basic principle is used for the tearing apart of Miguel, who has been bitten and gone over to the zombies, letting them into the compound — though they still rip him to shreds. A like fate awaits the few surviving soldiers, including Rhodes, who is torn in half after being shot by Bub (Howard Sherman), Dr Logan's only 'success'.

Bub, an army vet, vaguely remembers how to salute and shoot — but he also responds in some physical way to books and Beethoven, learning how to operate the controls of a Walkman (again, the actor's contribution). When he discovers that Rhodes has shot Logan, his mentor and friend, in reprisal for using 'my men' as meat for Bub, he reverts to the killing mode, but does add a final salute to the captain.

ABOVE George A Romero, writer/director of *Day of the Dead* (1985), has little fear of the zombies he and Tom Savini have created. But then he says he likes them better than most of his human characters.

Because Miguel, in the same incident, has been bitten but not seriously injured, Sarah tries to save him by cutting off his infected arm with a machete — an effect that failed to work with the first model, until an assistant of Savini's used a spare rubber arm with the cut prefilled with wax. A grooved machete over the actor's real arm took care of his struggles while she tries to cut through the bone; and the last stage was a false severed arm and stump, with tubes for gushing blood.

Sarah's violence, here and in the escape through the zombies' tunnels, is presented as necessary and sparked by the situation. She is not an ideal, but an individual human coping with a series of crises. McDermott and John, instinctively peaceful men, almost over-anxious earlier on to avoid confrontation, are even more violent when pressed. McDermott takes off the top of a zombie's head with a shovel — done with a trick shovel by reversing the action, then using a dummy in long shot. However, the essential contrast between those who are alive in a real sense — the three escapees — and those who are either dead but alive (the zombies) or alive but dead (the soldiers and Logan) is maintained.

4

GETTING PHYSICAL

Whereas optical effects and make-up effects tend to maximize control and reduce risks (often that is their main purpose), physical effects, commonly full-scale and shot as live action, can involve dangers. Though stunt artists and stunt co-ordinators are frequently used to assess, and reduce, such risks, they cannot always replace the actors — who may in any case prefer to do their own stunts, within limits. Besides, stunt people are only human too.

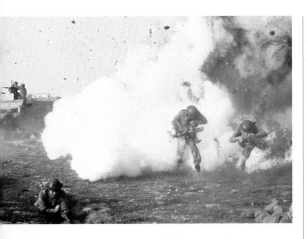

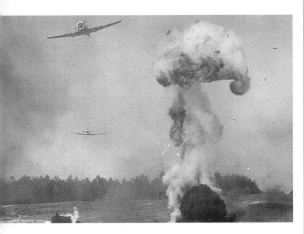

ABOVE & TOP In *A Bridge Too Far* (1977), explosives figure prominently, including the blowing-up of bridges. Veteran John Richardson handled physical effects, while Wally Veevers took care of photographic effects.

Action that features the elements of fire and water, explosions, gunshots, flying through the air, breaking furniture or glass, damaging cars and other highly visual types of movement or collision, especially involving the human body, are inherently dangerous to some degree. Film-making is work, and accidents happen at work — often but not always avoidably. Tragic incidents such as the death of Vic Morrow and two children during the making of *Twilight Zone the Movie* (1983) hit the headlines, rightly, but they are comparatively rare.

The physical effects co-ordinator, in particular, is charged with creating and supervising scenes that look dangerous or destructive without their being so in fact. In California, a licence system operates with regard to fire and explosives, known as Special Effects Pyrotechnics, with three classes, of which only the first can operate all effects permitted by law and by the relevant fire department.

The names of even the most experienced co-ordinators are little known, partly because they seldom get nominated for Oscars, other than in technical categories (non-statuette, and non-competitive since everyone who is named gets one). Though their work can be dealt with here only briefly, this is not intended to diminish its importance or on-screen impact.

FIRE:
FIRES, EXPLOSIONS, GUNSHOTS, GUNSHOT WOUNDS...

It is the area of physical effects that tends to give rise to anecdotes — you don't hear many great stories about travelling mattes. Fire and water are perhaps the most productive of tales, very few of which will be repeated again here. The aspects of scale and danger give rise to both thrills and comedy, especially if things go wrong — though going seriously wrong is no joke at all.

No doubt computer animation will eventually take over many effects that have stayed unchanged in principle — though perhaps safer in control — for decades. Kerosene or gasoline mixed with thickening

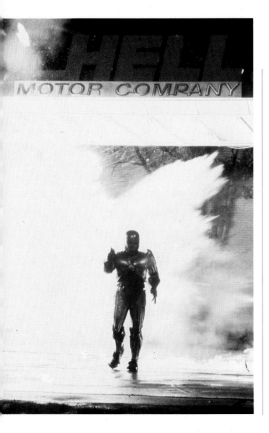

agents have been used for small patches of fire for years. But gas is more controllable (and portable in cylinders or tanks), especially if used in flame forks made of metal tubes with holes or in a fan shape. The more dangerous areas are where a whole setting is ablaze or a person is on fire, as in films about major fires (for example, *Towering Inferno*, 1974) or in war films. Stunt people are used for such effects, and need considerable protective clothing, and the action shot in short takes and with as few retakes as feasible.

Explosions can be done with high explosive, such as dynamite, for a rapid effect or with gunpowder for a slower one. If a set is to be blown up, it's generally cheaper to use a miniature and overcrank the camera to slow down the movements and make them look weightier, as when Morton's penthouse is blown up in *RoboCop*. Here the explosion is given an extra metaphorical force by the context: Morton has tried to get too *big*, too *high*. He's also 'high' in the sense of taking cocaine along with two call-girls, who exit hastily when Botticker, now known to be in league with Jones, arrives. The tension is built up as Morton tries to get the bomb before it goes off — it's a sort of large grenade. By contrast,

ABOVE In *RoboCop* (1987), RoboCop strides away from the wreckage of the gas station blown up by the obnoxious gangster Emil. Since all fire effects are potentially dangerous, it is probably a stunt-man rather than Peter Weller taking the easily disguisable role of RoboCop in this shot.

RIGHT In *RoboCop* (1987), ED 209 goes berserk and shoots a young executive, Kinney. In the film a miniature was matted on for the shooting; in this production shot the full-scale non-working model sufficed.

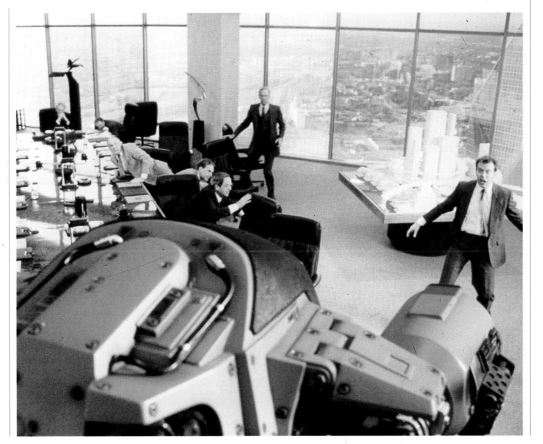

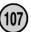

the explosion in which Leon (Ray Wise), high up on a crane, is eliminated with a cannon by Lewis, after dropping a load of girders on to RoboCop, is little more than a ticking off, though spectacularly, of one more villain.

RoboCop uses a similar weapon to terminate ED 209 — the full-scale, non-moving model was simply provided with pyrotechnic effects, such as flashpowder, then a small model with legs only, the rest having been blasted away, replaced the full-scale one. It was easy, since ED 209 was merely a machine all along – and an ineffectual one at that – to make his expiry comic.

Gunshot wounds have become increasingly realistic over the years, possibly because colour makes it necessary to show 'blood'. In the earlier gangster films — certainly up to and including *White Heat* (1949), at least — no impacts or wounds were visible, since red would in any case have photographed black against dark suits. Truffaut, in *Meet Pamela* (the film we see being made in *Day for Night*), maintains this old tradition when Alphonse (Jean-Pierre Léaud), as the son, shoots his father — a stand-in for the dead Alexandre (Jean-Pierre Aumont) — in the back; the stand-in is merely a dark figure in the snow. In *RoboCop* as in most modern films, small charges and bags of blood are used copiously, for the death of Jones and, still more, for that of Kinney (Ken Page), mistakenly shot by ED 209. Because ED 209's firing effects are done by stop-motion, the flashes from his guns are actually strobe lights, taken out of the flash unit of a still camera, and added in-camera, according to very precise calculations, on a second pass of the movie camera.

ABOVE Sonny Corleone (James Caan) is tricked by his brother-in-law and ambushed at a toll gate in *The Godfather* (1972). A state-of-the-art shoot-up with multiple hits and bags of blood ensues. Special (physical) effects by A D Flowers, Joe Lombardi and Sass Bedig.

RIGHT *The Fog* (1980) was John Carpenter's follow-up to *Halloween* (1978), this time starring Janet Leigh as well as her daughter, Jamie Lee Curtis — though Carpenter's wife, Adrienne Barbeau, took the leading role. Richard D Albain Jr, following his father into the business, produced the fog; Rob Bottin fashioned the make-up for the ghostly sailors.

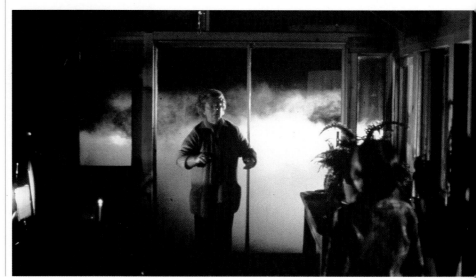

 108

The deaths of Bonnie and Clyde (already referred to) and of Sonny Corleone (James Caan) in *The Godfather* not only heralded the new style but have hardly been equalled since, even in Brian De Palma's remake of *Scarface* (1983), for bloodiness or emotional impact. More recently, the dying Vietcong sniper (Ngoc Le) in *Full Metal Jacket* elicits a mixture of terror — she has already killed three of the platoon and was just about to get her fourth — and pity. She is in mortal terror herself even before she is fatally wounded and in agony, begging for death. Finally, then, it is not the amount of blood or the loudness of explosions or the brightness of fires that counts, but the narrative context that gives them importance — or not.

ABOVE The disastrous *Hurricane* (1979) was a too-late remake of John Ford's *The Hurricane* (1937), masterminded by Dino De Laurentiis and directed by the Swede Jan Troell. The SFX team was led by Glen E Robinson whose career started with *The Wizard of Oz* (1939).

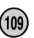

AIR:
WIND, FOG,
FALLING, FLYING...

Wind machines, now usually aircraft engines, are a traditional theatrical device in the movies. Wind has the fascination of an invisible force, visible only in its effects. As far back as *The Wind* (1927), a delicate Eastern woman, Letty (Lillian Gish), was terrorized by the Texas wind and flying sand, which refused to hide the body of the man she had killed in self-defence. In *Key Largo* (1948), the storm that confines the characters to a hotel in the Florida Keys almost becomes a character in itself as it crystallizes the tensions and violence when Rocco (Edward G Robinson) and his gang take over. *The Hurricane* (1937), a minor John Ford epic, was remade in 1979 as *Hurricane,* to little artistic or commercial acclaim ($4.54 million NA rentals on a budget of $22 million). James Basevi's effects in the original version were long unequalled, as was his earthquake in *San Francisco* (1936). Arnold

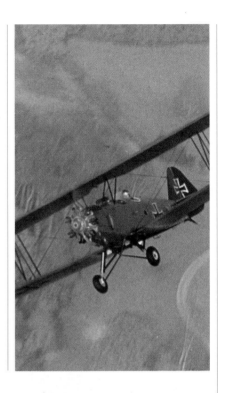

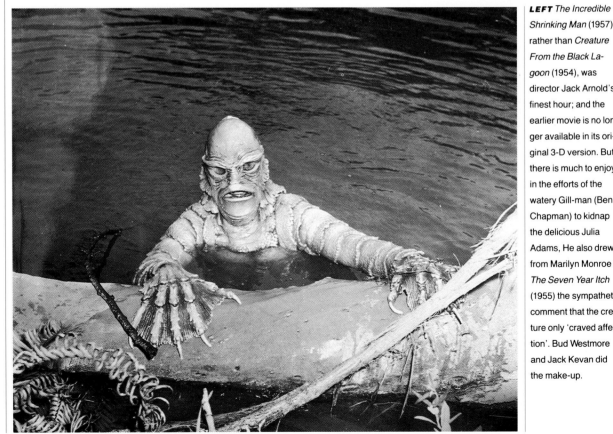

LEFT *The Incredible Shrinking Man* (1957), rather than *Creature From the Black Lagoon* (1954), was director Jack Arnold's finest hour; and the earlier movie is no longer available in its original 3-D version. But there is much to enjoy in the efforts of the watery Gill-man (Ben Chapman) to kidnap the delicious Julia Adams, He also drew from Marilyn Monroe in *The Seven Year Itch* (1955) the sympathetic comment that the creature only 'craved affection'. Bud Westmore and Jack Kevan did the make-up.

110

Gillespie's tornado or 'twister' in *The Wizard of Oz* (1939) is also well
remembered from that period.

Fog, often produced by combining smoke (from slow-burning
naphtha or bitumen mixtures) with dry ice (carbon dioxide), used to be a
cliché of Hollywood's London — based on all-too-true reality until the
late 1950s. (Hammer films revived the cliché with enthusiasm.) But
John Carpenter's attempt to elevate fog from an incidental effect to a
quasi-independent source of terror in *The Fog* (1980) was not a
success. Like night, it is what humans do in it that counts; man is
ultimately the most frightening monster of all — especially in real life, as
the newspapers reveal. Perhaps the finest cinematic expression of this
is in Alain Resnais's documentary on the Nazi concentration camps,
Night and Fog (1954), a masterpiece so powerful that some of his later
features hardly seem to come from the same hand.

Walking on air, or flying through it, has been a favourite illusion of
both stage and screen — it partly explains the eternal appeal of *Peter
Pan* in the theatre (it was also filmed in 1924 and by Disney in 1953).
Reference has already been made to the *Superman* series, with its use
of wires (two, fixed to a hip harness) or a pole to support the actor/
stuntman at different times. In *2010,* the space sequence was
engineered using wires, as already described; but when Chandra was
weightless inside HAL's 'brain', Bob Balaban was supported on a pole

that was hidden by his body, and the whole set, only a few feet wide and hence permitting little leeway, was jiggled up and down slightly on pneumatic supports to increase the feeling of floating in mid-air.

Falling down great heights, as in *RoboCop* and *Batman*, tends to be done as a mixture of stunt (for the start) and animation or a dummy (or both) for the rest. Falling or crashing through windows can be riskily done with real glass (Clarence in *RoboCop*) or poeticized into a purely visual spectacle, as in the death of the snake-woman Zhora (Joanna Cassidy) in *Blade Runner*, smashing through pane after pane of pink-lit store windows. The death of Pris (Daryl Hannah), after her own aerial attacking tricks on Deckard, is more horrifying just because it is more overtly mechanical. She's a cross between an overwound, self-destructing toy and a furiously dying insect, drumming her heels and elbows in hectic rhythm on the floor.

The flying stunts in such films as *Von Richtofen and Brown* (1971; GB: *The Red Baron*), about the World War I air duel of the German and Canadian aces, and *The Great Waldo Pepper* (1975), with Robert Redford as a 1920s stunt pilot, and the spectacular aeronautics of *The Right Stuff* (1983) would need a whole section to themselves; but this one would be incomplete without a passing mention of them.

ABOVE This location shot for *Jaws II* (1978) illustrates one great truth in film-making: natural light is never quite right for Hollywood. All cinema is artifice, never more so than when it seems most 'natural' (the fish is fake too). Mechanical effects: Roy Arbogast. At $50.4 million in rentals, the sequel was a long way off its 1975 predecessor's $129.5 million but still within the top two-thirds of the all-time 100 box-office leaders.

WATER: FLOODS, RAIN, SNOW, ICE...

At one time every studio had its own tank — or several, indoor and outdoor — on the back lot. The MGM one survived to be used by *2010*. The indoor tank at Ealing, once used for war movies like *San Demetrio London* (1943) and *The Cruel Sea* (1952), was still there as late as 1989, conveniently crossable by a little bridge, though the studio had been used for BBC films since 1956.

Such effects as the parting of the Red Sea in *The Ten Commandments* (1956), largely the work of John P Fulton and basically achieved by shooting in reverse and matting in shots of the actual Red Sea, have gone down in movie mythology. Water irresistibly calls forth monsters like the *Creature From the Black Lagoon* (1954) or, on a bigger scale, the great white whale in *Moby Dick* (1956), and 'Bruce', the killer shark in *Jaws* (1975) — huge mechanical creations that frequently cause mayhem when shooting and

ABOVE The killer great white shark from *Jaws* (1975) was simply named 'Bruce'. Effects are credited to the otherwise little-known Robert A Mattey.

BELOW In *The Shining* (1980), Wendy (Shelley Duvall), equipped with a knife to protect herself and her son from her crazy husband, makes her way through real snow in front of the Overlook Hotel, Colorado (actually the Timberline Lodge, near Mount Hood, Oregon). The climactic maze scene, however, was a set in Elstree and featured the imitation variety of snow.

ABOVE Lillian Gish claimed, all too credibly, to have permanently damaged her hand through trailing it in icy water for D W Griffith's *Way Down East* (1920), in which she played an innocent rural girl lured into a phony marriage and a real pregnancy (the baby dies). Driven into the snow, she barely survives — and it was touch and go for Miss Gish too.

end up as the main talking point of the films in which they were meant, presumably, to serve the actors. (At least *Moby Dick* did not have three — or was it 22? — sequels.)

As rain water pours down as if from a giant studio watering can on Gene Kelly in what is probably the most memorable dance number in cinema that does not include a woman, the title song from *Singin' in the Rain* (1952). Photographed in layered depth and painstakingly matted on, the acid rain in *Blade Runner* sets the tone for the film, a kind of deadly natural weeping against which any attempt to discover meaning in life seems almost vain.

Natural snow, in Norway, is the background for *The Heroes of Telemark* (1965), where it threatens much of the time to outshine the story. The artificial variety provides a freezing setting for the climactic chase through the maze in *The Shining*. In *Day for Night* it is laboriously swept and brushed on to the sunny Nice set of a dark Paris street for the scene where the 'father' is shot, where it expresses mourning for Alexandre, killed in a road accident, and killed again in his absence for the movie-within-a-movie, which must have its ending too.

The ice floes in D W Griffith's *Way Down East* (1920) were nearly all real and Lillian Gish suffered again, this time much of it not just acting — stunt doubles were used only occasionally. In Eisenstein's *Alexander Nevsky* (1938), for the famous battle on the ice (for which Prokofiev provided the music), the ice floes were made of water glass (sodium silicate) supported on pontoons, since he was shooting near Moscow in high summer. The snow he used was a mixture of asphalt, water glass, white sand and chalk. Nowadays plastics like polythene and polystyrene tend to be preferred, provided they are to some extent fireproofed. Paper and sawdust are sometimes used too, but salt is generally considered too corrosive for the good of the cameras and other equipment, though it looks great.

EARTH: QUAKES, VOLCANOES...

Mother Earth has been a temperamental source of danger in many films besides *San Francisco. Earthquake* (1974) was notable for the matte paintings of Albert Whitlock in conveying, along with many miniatures, the destruction of Los Angeles. Less satisfactory, on its first run, was the Sensurround sound effects that shook the seats with highly amplified deep rumbles. Similar vibrations can be experienced

nowadays at certain rock venues, in some cases actually ex-cinemas, where the distraction of watching a film has been entirely abolished in favour of pure sensation, or hearing with your feet.

Volcanoes can occasionally be a source of spiritual wisdom, as for Karin (Ingrid Bergman) in *Stromboli* (1949); but more often they're a dangerous nuisance, as in *When Time Ran Out . . .* (1980), where the South Sea island of 'Kalalou' is largely devastated — none too convincingly, it must be admitted. *Krakatoa — East of Java* (1969) is perhaps best known for the geographical howler in its title; but the special effects by Eugène Lourié (a Russian-born Frenchman who worked with Jean Renoir in both France and the USA) apparently stood up well even in their first-run screening in Cinerama. Lourié reputedly drew some of his material from the documentary footage of Haroun Tazieff, one of whose early short films had coincidentally been about Stromboli. Much earlier, *Aloma of the South Seas* (1941) had reunited the stars of *The Hurricane,* Jon Hall and Dorothy Lamour, for another natural trauma — volcanoes and South Sea islands seem to have an elective affinity. Who can forget the appalling Maria Montez — two of her — in *Cobra Woman* (1944) her evil persona being a snake priestess? Once again, a quasi-orgasmic eruption provided the climax to, in this case, a blatantly camp specimen of Polynesian exotica from Universal, then struggling to get over its B-movie rating and recover some traces of its early glories.

Although the Finnish *Earth Is a Sinful Song* (1973) contains no special effects, apart from one semi-intentional drowning, its title seems to sum up many film-makers' attitude to the planet. Perhaps the desire to escape to other planets and maybe find friendly aliens there, as in *Slaughterhouse-Five* (1972), a rather unsatisfactory version of Kurt Vonnegut's most personal novel (1969), is inspired partly by man's increasing unease on this one. But fantasy cinema is not always escapist or juvenile — it may also be a way of searching for alternatives and new visions. One of the greatest modern film-makers, Ingmar Bergman, has increasingly introduced fantasy elements into his later films, such as *Fanny and Alexander* (1982), along with an increased, if guarded, measure of hope for the future, as well as reconciliation with the past.

BELOW *The Devil at 4 O'Clock* (1961) was one of the many volcano movies that have borrowed documentary footage for spectacular effect.

CONCLUSION

PUTTING IT
ALL TOGETHER

Several of the previous examples, particularly *Blade Runner* and *RoboCop*, have illustrated the way in which multiple types of effects work together for a total effect. Many other examples could have been cited — from the *Star Wars* and *Star Trek* series, for instance. One final example here is *The Abyss* (examined in greater detail in *Cinefex* 39, August 1989).

ABOVE *The Abyss* (1989) carried underwater photography to lengths hardly previously attempted in fiction films; but its confusion of genres, episodic storyline and unsympathetic characters prevented it from being a crowd-pleaser (or critic-pleaser). Here a stuntman stands in for Ed Harris.

Though neither a commercial success (earning $28.7 million on an estimated budget of $50-60 million) nor altogether a critical one, *The Abyss* (1989) had, even in the year of *Batman* and *Ghostbusters II,* by far the most elaborate and ambitious effects. James Cameron's work on *The Terminator* and *Aliens* had prepared him to tackle a larger project, as well as a more personal one. (The press reports of how his marriage with producer Gale Anne Hurd broke up while they were telling the story of an estranged couple being reunited will receive no further comment here.)

Since it was basically an underwater film, the hunt for locations was the first problem, eventually solved when they came across an uncompleted and abandoned nuclear power plant in South Carolina. The concrete shell of what would have been the reactor became the main tank, holding 7.5 million gallons (34.1 million litres) of water. A nearby pit, the derelict foundations for the turbine, became the 2.5 million gallon (11.4 million litre) miniature tank. Not only much of the regular shooting but some of the bluescreen and rear projection work was done underwater — possibly for the first time. The story spanned the realism of dismantling a nuclear warhead at a great depth and the fantasy of aliens, whose presence has provoked a paranoid military reaction. Whereas Cameron seems to have become disillusioned with the military mind since his chummy marines in *Aliens,* he has come to think of aliens as potentially friendly as well as powerful. Though the aliens themselves were translucent puppets, and the main technical problem was lighting them from inside at multiple points, the pseudopod made of water, in which the aliens manifest their control of the environment, was of a different order of technology.

ILM's computer graphics unit was subcontracted to produce convincing 3-D imagery, and succeeded brilliantly. The form was based on clear-resin maquettes; but the pod also has to show its friendly

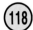

intentions by humorously transforming its 'face' into water sculptures of Lindsey (Mary Elizabeth Mastrantonio) and Bud (Ed Harris), mimicking their expressions. A further challenge was the shot where part of the pod, cut off by Lt Coffey (Michael Biehn), turns back into ordinary sea water — this involved elaborate mattes, a horizontally split screen and some skilful electronic painting. In all, it took eight months' work by a team of about 20 to produce some 75 seconds of screen time — this compares with a total stunt team of only 22.

On the action-adventure side, there were such highlights as the collapse of the crane on to the underwater complex (done with miniatures) and the battle of the underwater craft between the now completely crazed Coffey and the reconciled couple. Their reunion is sealed when Bud 'drowns' Lindsey in saving her from the damaged vehicle and then brings her back to life with possibly the most extended (if functional) screen kiss since the days of Hitchcock's circular tracking shots and swooning close-ups.

Unfortunately, all this personal relationship side fails to convince. Mastrantonio (so good in *The Color of Money* (1986) as the tough-minded girlfriend of Tom Cruise's young hustler) comes on initially as a strong, independent, Hawksian woman. However she later collapses — has the brush with death affected her brain cells? — into a tearful, stay-at-home (or at least at-base) wifey while Bud plumbs the abyss from which he seems unlikely to return alive. The grinding switch of cinematic gears from Howard Hawks to Steven Spielberg as Bud is saved by the aliens is none too happy either. Cameron has not Spielberg's sincere if

BELOW In *Ghostbusters* (1984), the Ghostbusters run into trouble when the Sumerian demi-god Gozer, initially manifested as a woman (Slavitza Jovan), accidentally turns into a giant Staypuft Marshmallow Man — actually a model made by sculptors Linda Frobos and Bill Bryan. The intrepid team consists of (from left) Harold Ramis, Bill Murray, Dan Aykroyd and Ernie Hudson.

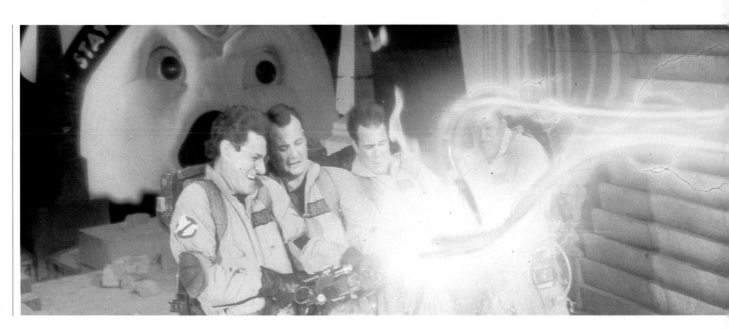

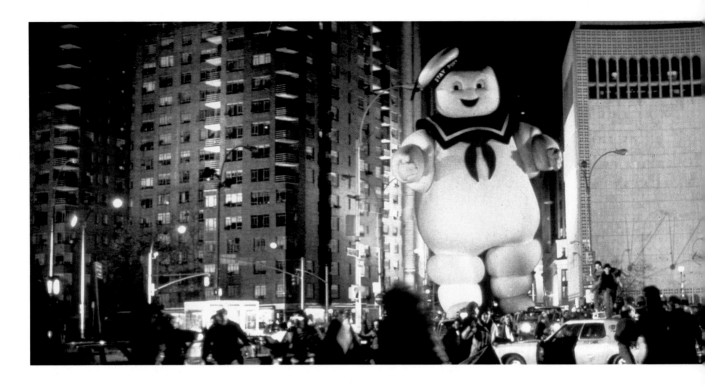

schmaltzy sentimentality nor the feeling for boyish comradeship that motivates Hawks's best westerns and adventure films. His allegiance is actually to the couple and the nuclear, if fragmented, family (absent son in *The Terminator;* no father-figure in *Aliens*). However, there's little point in rapping Cameron for failing to get his human interest up to the level of his effects in a year when the gloomy melodramatics of *Batman,* and its weirdly Freudian entanglements, took it up to number 4 ($150.5 million) in *Variety*'s all-time rental champs.

THE MUSIC OF SOUND

The Academy, as mentioned before, notices Best Sound Effects Editing, most years, as well as Best Visual Effects. Not uncommonly, indeed, the same film takes both awards — *ET* in 1982's films, *Aliens* for 1986, *Who Framed Roger Rabbit* for 1988 — but the whole area has become increasingly specialized. The casual old days when about half the sound effects in British films were done by a lady with the homely title of 'Beryl Footsteps' are long gone. Nowadays she would be a 'Foley artist', part of a team with its own supervisor and recording people, not that the increased professionalism that Jack Foley brought to the recording and fitting of footsteps and other body movement sounds is to be regretted, of course.

ABOVE The Staypuft Marshmallow Man in *Ghostbusters* (1984) invades Manhattan and causes general panic. He was probably built in several scales, all much smaller than he appears here; his movements were mainly done by an actor/stuntman, but some shots may have been stop-motion.

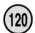

One important use of effects is to increase the reality of miniatures and models: ED 209 in *RoboCop* is fearsome partly because of his heavy footsteps, loud gunfire and the sounds of his encounters with RoboCop. Similarly, his almost babylike cries of rage and frustration when brought down by a staircase anthropomorphize him to humorous effect.

In both *Ghostbusters* (1984) and *Ghostbusters II,* the giant figures, the Marshmallow Man and the Statue of Liberty, depend on sound effects to seem big. The comic sound effects that accompany the ghostbustings reassure the audience that it is all a comedy with fantasy-thriller overtones, an expensive offshoot of *Saturday Night Live* — also profitable, since *Ghostbusters* was still 6th in *Variety*'s 1990 listing, at $130.2 million, while even the perfunctory *Ghostbusters II* made it to 42 with $61.65 million.

The gunshot effects and other visual effects already discussed often owe their sense of reality as much to the soundtrack as to the visuals. Pauline Kael's famous, not so innocent, summary of American cinema as 'Kiss Kiss Bang Bang', though open to scurrilous reinterpretation, does sum up much of the movies' appeal. When Truffaut said the audience rightly expects the cinema to provide pretty people doing pretty things, he left out the other complementary half in which both pretty and ugly people to ugly things, preferably with some style.

THE SOUND OF MUSIC

A minor classic of 'ugly people doing ugly things' with some style, *The Good, the Bad and the Ugly* (1966), exemplifies the use of music as an effect. Ennio Morricone, now in his 60s, has been providing his quirky scores, ranging from odd, modernistic sound effects to the most plangently weepy Puccinian quasi-operatic sounds, for Italian and international films since 1960. His French equivalent, Georges Delerue, as much associated with Truffaut as Morricone is with Leone, has been almost equally prolific. But the great tradition of Hollywood music was established in the 1930s and '40s by expatriates from Germany, Austria and Eastern Europe (Max Steiner, Miklos Rozsa). Recent films like *The Abyss* and *Batman* differ little from the films of that time in assuming that a heavy orchestral backing, broadly in the Romantic tradition, if sometimes jazz-influenced (Jerry Goldsmith) or with rock associations, is necessary to sustain and control the audience's emotional response (the main difference being that they save it for key sequences, rather

(121)

than having an almost continuous wash of sound). John Williams, particularly in his Spielberg/Lucas connection, is an outstanding recent example — he even gets his scores replayed (if critically ignored) at concerts.

A similar figure at the art-movie level (though concerts of his work are more likely to be savaged rather than ignored by the music reviewers) is Michael Nyman, Peter Greenaway's regular provider of pseudo-baroque backings which work extremely well with the films — try to imagine *The Draughtsman's Contract* (1982) without the music. Fantasy cinema especially needs some extra help from music and sound to make it real. Bernard Herrmann's 'score' for *The Birds,* as an example, uses no conventional music at all, but only 'real' sounds to stress the menace of the attacking birds.

To conclude, an effect that's clearly special is dubbing. More precisely, it's a normal technique, especially in non-English speaking countries; but a special use is to dub a singing voice on a non-singing artist, usually a dancer (Cyd Charisse, Rita Hayworth). The voice of India Adams does not quite fit Cyd Charisse in *The Band Wagon,* one of the few flaws in that marvellous musical. But the remarkably versatile Marni Nixon managed to range from singing for Deborah Kerr in *The King and I* (1956) to Audrey Hepburn in *My Fair Lady* (1964) by way of Natalie Wood in *West Side Story* (1961). Since Julie Andrews did not need her services in *The Sound Of Music* (1965), she was permitted to appear there as one of the nuns' chorus.

LEFT At the end of *Close Encounters of the Third Kind* (1977/80), Steven Spielberg calls on all the resources of special effects, including elaborate model-work animations, lighting and, of course, music to persuade the audience to share an ecstatic experience of benign wonder, free of fear.

COMPUTERS: THE FUTURE IS ALREADY HERE...

Whole books have been written about the uses of computers in film-making, of which N Weinstock's *Computer Animation* (New York, 1987) is a literate and comprehensive example. Computer graphics are electronic in principle, and are viewed on screens that are basically video screens and nothing to do with the traditional photographic technology of the cinema. There is no film — though the images can be transferred to film.

In the past, television and video have developed their own technologies separately from film. They might even be in parallel, the obvious example being chroma key (colour separation overlay), which has a close resemblance to blue-screen travelling matte. Indeed, blue was chosen as the background colour for the same reason — its distance from normal skin tones. The output of two cameras (originally monochrome, but the advent of colour technology improved the process) was fed into one screen, but with instructions to switch from camera 1 (figure in front of blue screen) to camera 2 (background plate, still or moving) each time the moving spot on the raster line reached blue, or a particular shade of blue. In this way we got the newsreader reading the news, blithely undisturbed by the busy newsroom 'behind' him/her.

If this was so easy, and instant, compared with the laborious process of travelling matte, why is computer animation used when by contrast it is so long and expensive to do? The short answer is that it depends what you want. Images intended to be shown on TV or video can be made at the fairly low resolutions adequate for the small screen — the few hundreds of lines' difference between broadcast TV and videocassettes (where the signal doesn't need to travel through the air and is not subject to interference) is insignificant from the point of view of transfer to film stock. Most computer graphics firms support themselves mainly by producing or contributing to TV commercials (ads) and music videos, so resolution and fine image quality are no great problem to them.

Computer images can be 2-D or 3-D (that is apparently 3-D through perspective effects, shading etc). Whereas 2-D images can be basically mathematical and laid out in lines, straight or curved, 3-D images tend to need input either by hand from an artist or by copying 2-D or (images of) 3-D originals. These tend to be either geometrical forms — which are

ABOVE In *On a Clear Day You Can See Forever* (1970), Dr Chabot (Yves Montand) misses green-fingered Daisy Gamble (Barbra Streisand), and decides to call her back by projecting his voice into anyone she meets — including an old woman and a dog — until she is forced to return to him for peace and quiet. Though technically quite simple (the dog must have been the trickiest, but TV ads now do it all the time), the dubbing of his song, 'Come Back To Me', on so many different characters makes a startlingly effective sequence. One of its tricks is that the song is continuous, but the 'singers' are various in time and place — yet each one picks up perfectly from the preceding one. a very precise piece of editing as well as *mise-en-scène*.

mathematical but can get very complex — or forms that don't conform to a regular pattern, that is most natural and many mechanical shapes.

Fantasy film-makers can make use of the simpler graphics for limited purposes, for example the reams of stuff fed into the video screens aboard the *Leonov* in *2010*. But the interesting area, already touched on in *The Abyss,* is the interactive one, where artists can modify and combine shapes in complicated ways, truly *special* effects.

The New York company of R/Greenberg has already been mentioned briefly. The 'R' stands first for Richard, who is the design specialists, but also for his brother Robert, the businessman and manager. They did the original titles for *Superman the Movie* and created much of the thermal imagery for *Predator* (1987), in which Schwarzenegger was the good guy — he was better as the evil Terminator. They have contributed to several of Woody Allen's films, including some of the elaborate effects in *Zelig* (1983).

The future for computer graphics seems unlimited, whether in terms of animation films or live-action, and yet it has so far been rather slow in making its full potential impact. But it seems that the 1990s are destined to be the era of breakthrough.

The other main area of computer use is in the control of camera

RIGHT In *Carmen Jones* (1954), it is unfortunate that Harry Belafonte as Joe (Don José) and Dorothy Dandridge (Carmen) were not allowed to sing as well as speak their roles, however excellently Marilyn Horne and LaVerne Hutchinson dubbed them.

SPECIAL EFFECTS

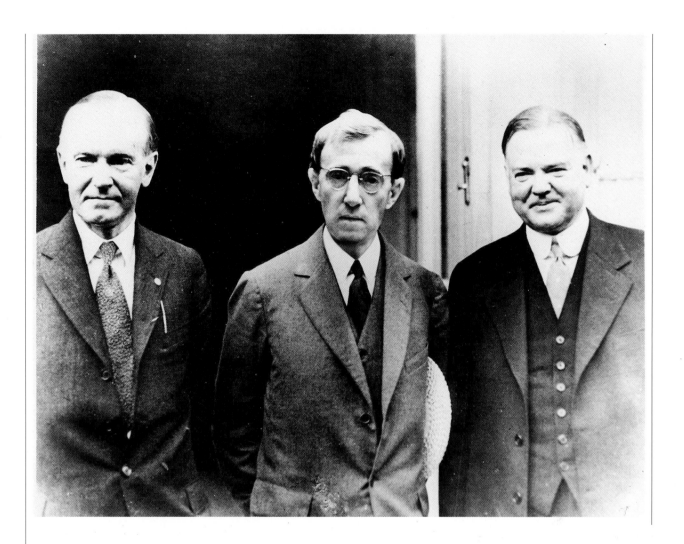

movements on tracks and on their mounts. The ability to repeat movements exactly, time after time, was the big advance of the 1970s, and was pioneered in particular by John Dykstra. Both in-camera effects and matting become much more exact; and the models need not move if the camera does. This aspect of computer use is no longer a new frontier; but it has become an essential tool. Computer control has already been applied to the animation stand and even to such accessories as boom arms.

Unfortunately, scripts still have to be written (and rewritten) by people — or is that fortunately? The nightmare of the great Cambridge critic, Dr F R Leavis, of a machine that could write poetry, is not yet with us. Even if it were, we would still need critics (ie good readers) to tell us if it were poetry or not, and if it were good poetry or not. Androids don't read books. You, who read this one and watch the movies, can never be computerized.

ABOVE Zelig (Woody Allen) is flanked by two US presidents, Calvin Coolidge (left, 1923-9) and Herbert Hoover (1929-33) in Woody Allen's *Zelig* (1984). This appears to be one of the few matte shots in the film, which, according to cinematographer Gordon Willis, depended more on re-creations and clever cutting than on optical trickery.

INDEX

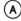

BIBLIOGRAPHY AND ACKNOWLEDGEMENTS

My largest debt in preparing this book has been to the specialist American magazines, *Cinefantastique* (ed: Frederick S Clarke) and *Cinefex* (ed: Don Shay). Without their valuable work, it would have been impossible to give the details of individual films which bring generalizations to life — though I have been able to use only a tiny proportion of the information available on any particular film, and must take full responsibility for selection, interpretation and (inevitably) simplification, as well as critical comments on the films discussed. In addition to the editors, the writers whose work I have drawn on include: J D Shannon, P M Sammon, P Mandell, J Bendit, J Van Hise, K B Counts, D Scapperoti, M L P Carducci, G Lovell, J R Fox, C Meeks, P R Gagne, D Bartholomew, A Jones, C Wolter, T L White, F A Levy. My next largest debt is to an old friend, now a Hollywood producer (*Honey, I Shrunk the Kids*), Tom Smith, who not only wrote a lucid and beautifully illustrated book about *Industrial Light & Magic* (New York, 1986), but kindly sent me a copy too. The other books I have referred to most, apart from those mentioned in the text, fall into several categories:

REFERENCE

T Baur & B Scivally, *Special Effects and Stunts Guide* (Beverly Hills, 1989)

I Konigsberg, *Complete Film Dictionary,* (London, 1988)

D Wingrove, *Science Fiction Film Source Book* (London, 1985)

TEXTBOOKS

Z Perisic, *Special Optical Effects in Film* (London, 1980)

B Wilkie, *Creating Special Effects for TV & Films* (London, 1977)

INTRODUCTORY

J Culhane, *Special Effects in the Movies* (New York, 1981)

C Finch, *Special Effects: Creating Movie Magic* (New York, 1984)

D Hutchinson, *Film Magic* (London, 1987)

A McKenzie and D Ware, *Tricks of the Trade* (London, 1986)

The British Film Institute Library had superb resources for research, and the London Library provided a fine environment to work in. I am grateful to the staffs of both indispensable institutions.

CREDITS

Key: t = top; *b* = bottom; *l* = left; *r* = right: *c* = centre.

British Film Institute: pages 14 *b*, 20, 23 *t*, 31, 123. **Joel Finler Collection:** pages 8 *t b*, 10, 15, 19, 21, 23 *b*, 24, 25, 26, 28 *t*, 29, 30 *b*, 32, 33, 34, 38, 39, 40, 42, 43, 44, 45 *t c b*, 48, 50, 51 *t b*, 53, 55 *t b*, 56 *l r*, 58, 64, 65, 66, 67, 68 *t*, 72, 73, 74, 75, 76, 77, 80 *b*, 82, 83, 87 *t b*, 89, 90 *t b*, 91 *b*, 93, 94 *bl bc br*, 95 *t b*, 96, 97, 99 *b*, 103, 110 *b*, 115, 116, 119, 120, 125. **The Kobal Collection Ltd:** pages 19 *b*, 61, 62, 63 *t* (Columbia-EMI-Warner); 70, 85, 86, 88, 118 (Twentieth-Century Fox Film Corp.); 80 *t*, 81, 98, 99 *t*, 107 *t b* (Orion Pictures Corp.); 113 *b* (Warner Bros. Inc.). **National Film Archive, London:** pages 6, 9, 12, 13, 14 *t*, 16, 18, 22, 27, 28 *b*, 30 *t*, 35, 37, 46, 54, 60, 63 *b*, 68 *b*, 69, 71, 78, 79 *t b*, 84 *l r*, 92, 94 *t*, 100, 101, 102, 104, 106 *t b*, 108 *t b*, 109, 110 *t*, 111, 112, 113 *t*, 114, 122, 124.